C000131684

NORFOLK IN THE GREAT WAR

From Old Photographs

NEIL R. STOREY

AMBERLEY

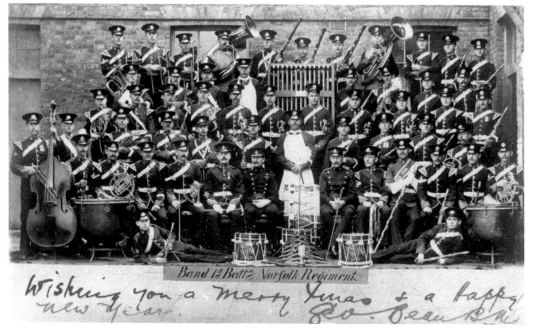

The band of 1st Battalion, the Norfolk Regiment, *c.* 1912, signed by Bandmaster George Dean, seated fifth from the left. The regimental band played at all manner of special occasions and ceremonial events, from parade grounds to bandstands wherever the battalion were serving.

First published 2017

Amberley Publishing
The Hill, Stroud
Gloucestershire, GL5 4EP

www.amberley-books.com

Copyright © Neil R. Storey, 2017

The right of Neil R. Storey to be identified as the Authors
of this work has been asserted in accordance with the
Copyrights, Designs and Patents Act 1988.

All rights reserved. No part of this book may be reprinted
or reproduced or utilised in any form or by any electronic,
mechanical or other means, now known or hereafter invented,
including photocopying and recording, or in any information
storage or retrieval system, without the permission in writing
from the Publishers.

British Library Cataloguing in Publication Data.

A catalogue record for this book is available from the British Library.

ISBN 978 1 4456 5436 2 (print)
ISBN 978 1 4456 5437 9 (ebook)

Origination by Amberley Publishing.
Printed in the UK.

Contents

Introduction

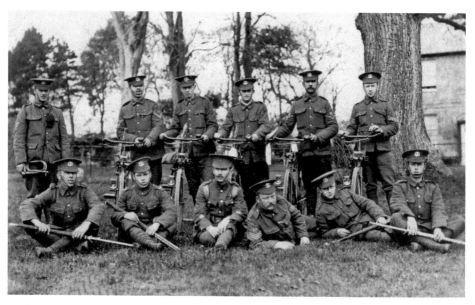

Cycle mounted signallers, 8th (Service) Battalion, the Norfolk Regiment, 1915.

It's hard to believe it was twenty-five years ago that my first books on the military history of Norfolk were published. Back then there was no internet to help research, there were no forums to easily compare notes or post enquiries, and no vast online archives of local and national newspapers. Such things were only the stuff of dreams as I ploughed through page after page of old newspapers, documents, books and ephemera in libraries and many private collections. I will add that there is still an awful lot of material that is not online and there is so much history just waiting to be found and explored in heritage centres and record offices. Sadly all those dear old boys and gals who had served or remembered the First World War that I knew and who shared their stories and memories with me have now passed away.

Any good historian is always learning and the discoveries we make constantly renew the love of the subject, and previously unknown stories shared with us by descendents stimulate a drive to learn more and share those stories with both students of all ages and the wider public. Recently the centenary years

of the First World War have generated an unprecedented interest in ancestors and local people who 'did their bit' both at the front and at home, and it has been my pleasure and privilege to lead, contribute to and be part of a number of special projects around the county exploring and documenting those special stories. There is still a lot of work to be done.

Although the First World War and its legacies are tinged with sadness and a sense of tragedy, we that come after should not forget that hundreds of thousands of lads joined up voluntarily in the firm belief that they were doing the right thing. We have no right to judge them. Undoubtedly, they were all part of a generation raised to be patriotic but all of the old servicemen that I spoke to, or whose accounts I have read or listened to, that joined up in those early years did so believing they were embarking on 'a great adventure' with their mates and did not want to miss out. And when it really came down to it amid the mud, blood and bullets, far more of them than we will ever know did extraordinary acts of bravery, not for medals but to help their mates in danger because they did not want to let them down, and a bit of wry soldier's humour to raise a smile certainly helped to get them through.

With all of this in mind I have selected over 200 poignant images from my archive for this new volume. It does not pretend to be an exhaustive and detailed tome – my other books such as *Norfolk in the Great War* and *Norfolk Goes to War* have far more detail. This book aims to evoke a portrait of Norfolk, its people and military forces during the war from original images. Every picture tells a story. There will be a few knowing smiles from those who have served their country as they spot the shared touchstones, hardships and comradeship of army life, past and present. I hope this volume will be useful both to those embarking on their journey of discovery of Norfolk's military history for the first time as well as those who have researched the subject for years. There is no glory in war but I think we can be proud of our Norfolk boys and gals and the way they went through so much during the conflict. Above all I hope the pictures and stories in this book will go some way towards a tribute to that generation that has now passed. We will never see their like again.

Neil R. Storey
Norwich, 2017

CHAPTER 1
The Road to War

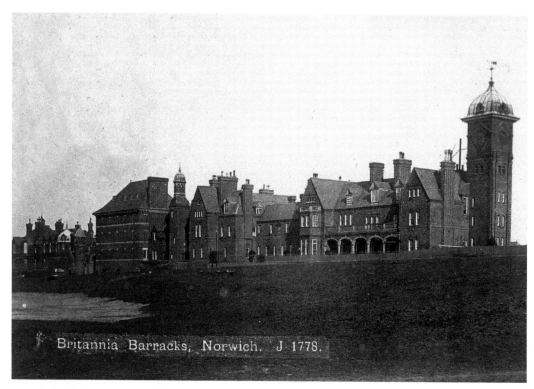

Britannia Barracks, Norwich, pictured *c.* 1910, was built in 1886–87 by Norwich City Council to be the first permanent depot of the Norfolk Regiment. Thousands of local lads walked through its gates as volunteers and marched out a few weeks later as soldiers during the First World War.

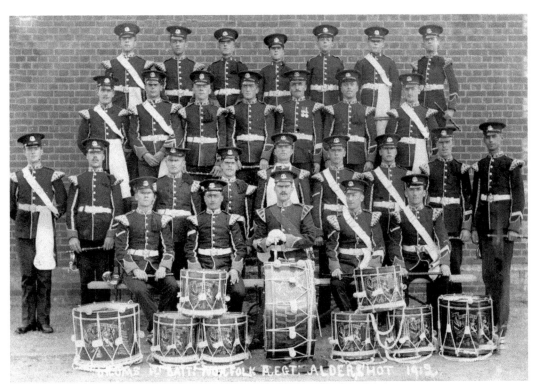

The drums of 1st Battalion, the Norfolk Regiment, Aldershot, 1912. The drums would often lead the battalion, playing on route marches and parades and always cut a dash in their scarlet tunics with yellow facings at tattoos and public events.

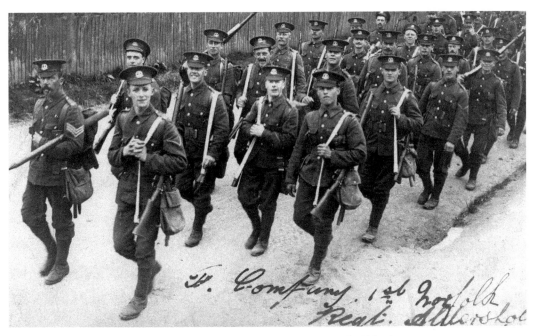

F Company, 1st Battalion, the Norfolk Regiment, on route march, Aldershot, 1912.

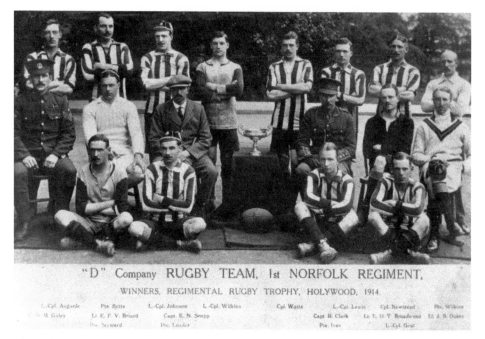

"D" Company RUGBY TEAM, 1st NORFOLK REGIMENT,
WINNERS, REGIMENTAL RUGBY TROPHY, HOLYWOOD, 1914.

L.-Cpl. Aagarde	Pte. Betts	L.-Cpl. Johnson	L.-Cpl. Wilkins	Cpl. Watts	L.-Cpl. Lewin	Cpl. Newstead	Pte. Wilkins
M. Galey	Lt. E. F. V. Briard	Capt. E. N. Snepp			Capt. R. Clark	Lt. E. H. T. Broadwood	Lt. J. B. Oakes
Pte. Steward	Pte. Leader				Pte. Ives	L.-Cpl. Gout	

The rugby team of D Company, 1st Battalion, the Norfolk Regiment, winners of the Regimental
Rugby Trophy, Holywood, 1914.

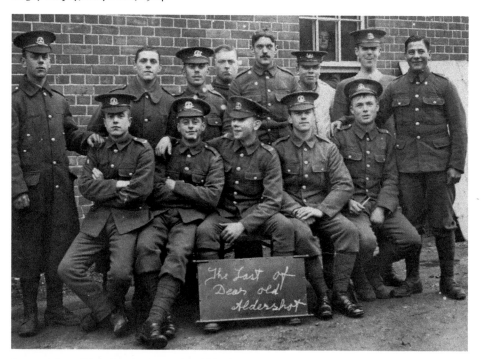

Some of the soldiers that had served in Aldershot, who were still serving with 1st Battalion, the
Norfolk Regiment, at Palace Barracks, Holywood, Belfast, 1914. The 1st Battalion was mobilized
from here on 4 August 1914 and embarked for France from Dublin bound for Le Havre, France
,on 14 August as part of the British Expeditionary Force. (Courtesy of Peter Harris)

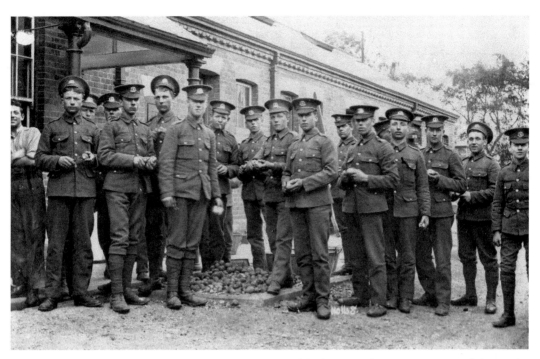

Soldiers of 1st Battalion, the Norfolk Regiment, 'spud bashing' (peeling potatoes), one of the regular tasks undertaken by other ranks soldiers. Palace Barracks, Holywood, Belfast, 1914.

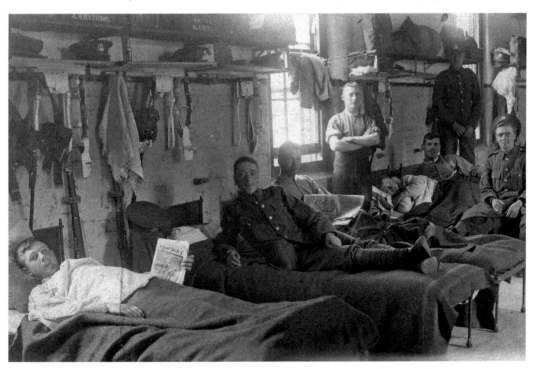

Off-duty soldiers from 1st Battalion, the Norfolk Regiment, relaxing in their barrack room, Palace Barracks, Holywood, Belfast, 1914.

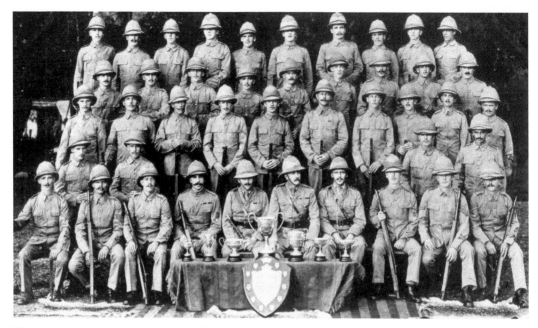

The prize-winning shooting team of 2nd Battalion, the Norfolk Regiment, 1912. In British regiments there would usually be one regular battalion on 'Home Service' in Britain and Ireland while the other was out serving as part of a garrison or on campaign somewhere within the British Empire. In the years immediately before the First World War, the Norfolk Regiment's regular battalions on foreign service were predominantly out in India.

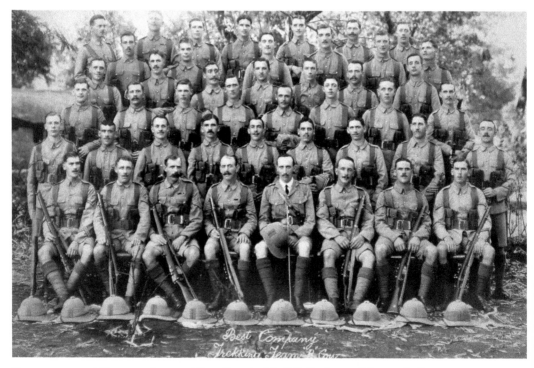

Best company trekking team from 2nd Battalion, the Norfolk Regiment, Belgaum, India, 1912.

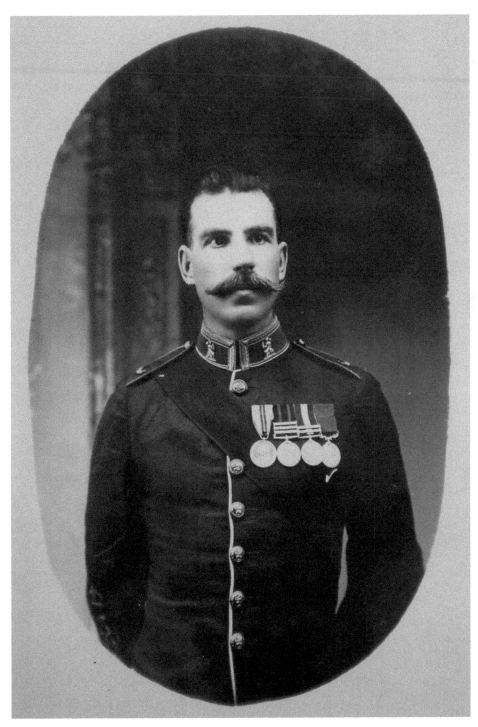

Regimental Sergeant Major Robert Semmence, 2nd Battalion, the Norfolk Regiment of Wymondham. He had served in the South African War (1899–1902), always led by example, had exacting standards and showed steady bravery in action. He was sadly killed in action at the Battle of Shaiba, southern Iraq, on 14 April 1915 aged forty.

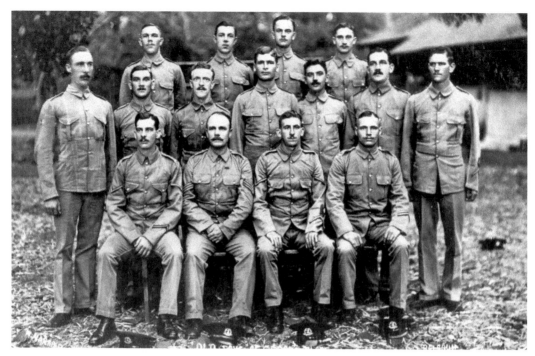

Old boys of Crook's Place School, Norwich, serving in 2nd Battalion, the Norfolk Regiment, Belgaum, India, 1912. Many local lads wanted to escape their home city for a while, fancied a bit of adventure, liked the smartness of a uniform and wanted a secure job, so they joined up with their local regiment and soon found they had comrades who had grown up in the same areas and even attended the same school.

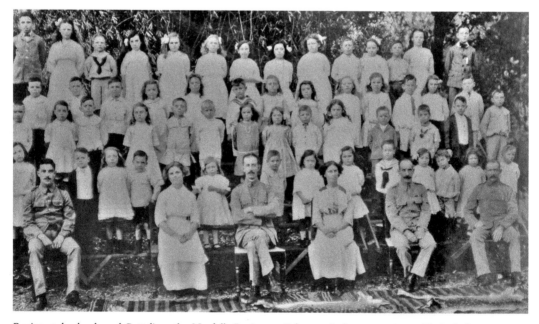

Regimental school, 2nd Battalion, the Norfolk Regiment, Belgaum, India, 1912. Army life in India was peaceful and the quality of life, although very hot, was good. A number of the officers and men of the battalion had their wife and children join them soon after arrival, and some had children born out there too.

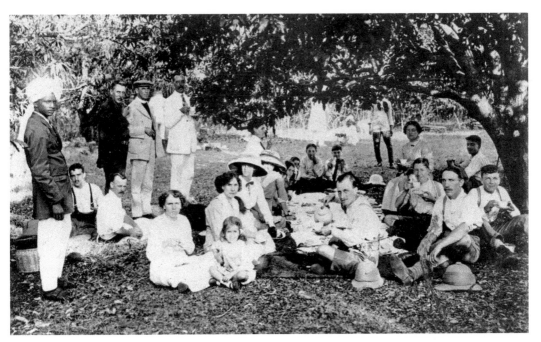

Men of 2nd Battalion, the Norfolk Regiment, enjoy a Sunday school picnic with their families in the shade at Fort Belgaum, India, 1912. Pay could go a long way out in India; even ordinary soldiers on a shilling a day could afford a servant to wash and press their uniforms and attend to the needs of the soldiers and their families – imagine that if you had grown up in one of the working-class areas of the city!

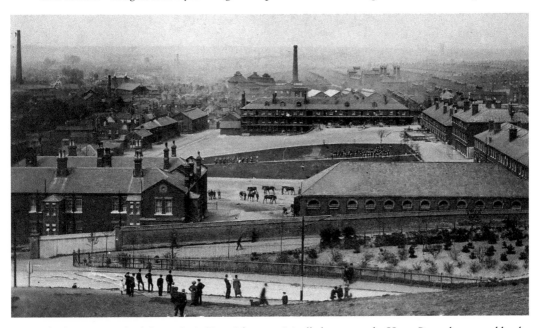

The first purpose-built barracks in Norwich was originally known as the Horse Barracks, erected by the government on the site of the old Pockthorpe Manor House at a cost of £20,000 in 1791. Over the years almost every cavalry unit in the British Army served some time there and numerous local lads fancied the smart cut of being a lancer, hussar or dragoon and joined up with them.

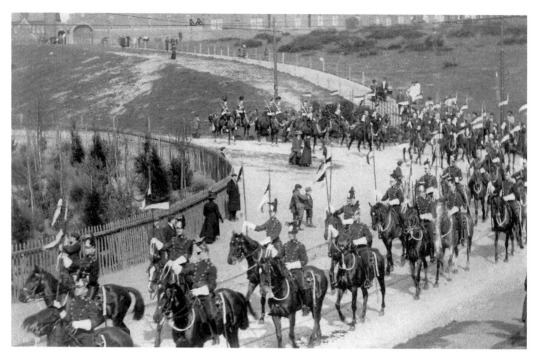

A common sight before the First World War, the XII Lancers trotting back down St Clements Hill to the Cavalry Barracks having had their exercises on the cavalry drill ground on Mousehold, *c.* 1912.

One of the troops of the King's Own Royal Regiment Norfolk Imperial Yeomanry in mounted review order at Northrepps Camp, 1905.

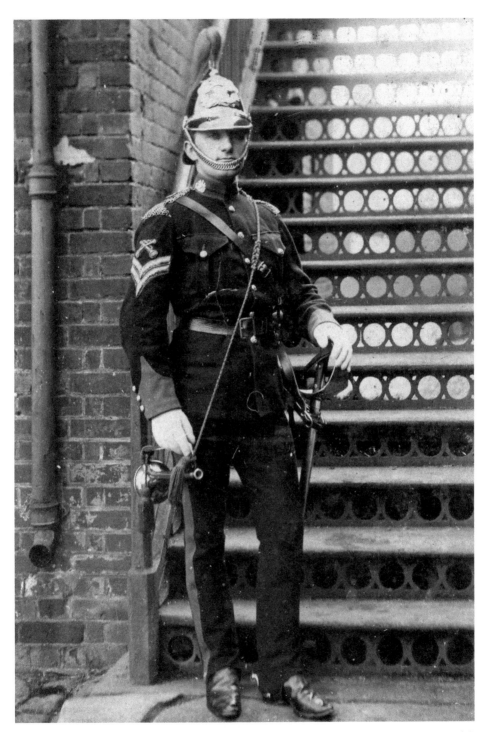

A squadron corporal of the King's Own Royal Regiment, Norfolk Imperial Yeomanry, in full dress uniform, *c.* 1909. Raised at the behest of Edward VII, the KORRNY drew its officers from the landed gentry and its ranks drawn predominantly from farming stock. They always had a fine turnout and were viewed by most locals as 'a cut above'.

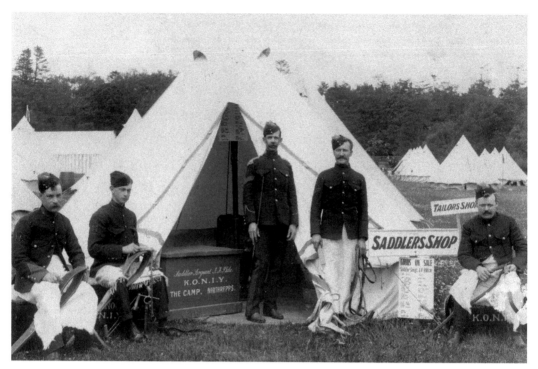

Saddler Sergeant Philo and the Saddlers of the KORR Norfolk Imperial Yeomanry, Northrepps Camp ,1905.

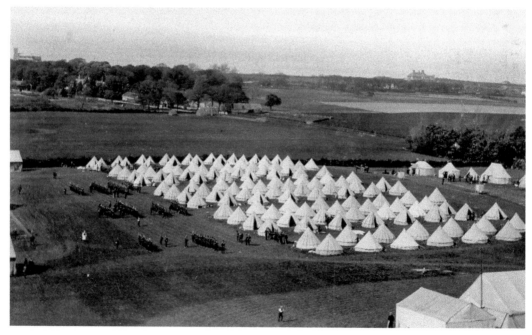

The KORR Norfolk Imperial Yeomanry Camp at Sheringham, May 1908. The coastline and countryside of Norfolk were regularly dotted with the white canvas bell tents and long marquees of military camps for both local and visiting territorial infantry and yeomanry units from all over the country during the first half of the twentieth century.

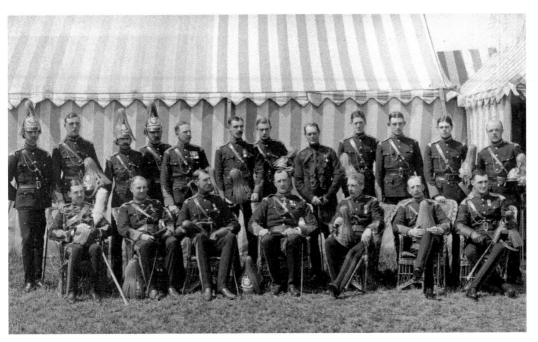

Colonel Henry Barclay of Hanworth Hall (seated centre), the man who had been entrusted by Edward VII with the raising of the King's Own Royal Regiment, Norfolk Imperial Yeomanry, pictured with his officers at Sheringham Camp, 1908.

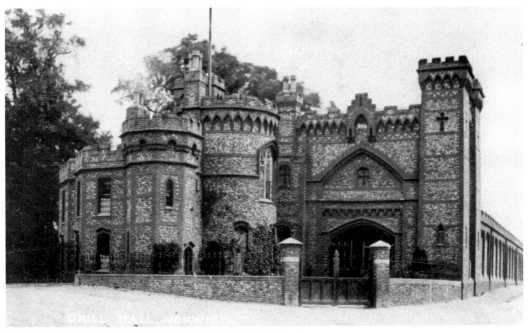

The Drill Hall, Chapelfield, c. 1910. The foundation stone was laid in May 1866 and it opened later that same year as a drill hall for local volunteer infantry. In 1908 it became headquarters of the 4th Battalion, the Norfolk Regiment. On mobilization in 1914 all ranks of the battalion (which drew its men from the city and south of Norfolk) were requested to report here on the morning of their mobilization, 5 August 1914.

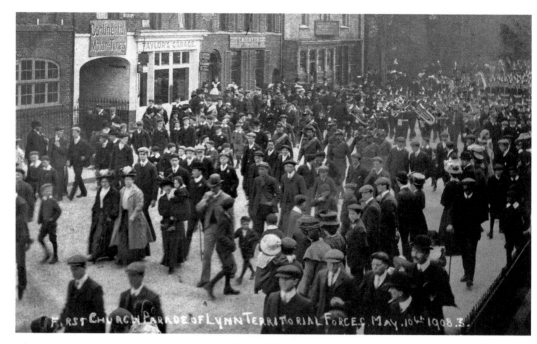

The first church parade of the King's Lynn Territorial forces on 10 May 1908. The old system of volunteer soldiers was transformed into the Territorial Force during the Haldane Reforms and the first parades of the new battalions raised specifically for the defence of the Britain in the event of a continental war drew a lot of public interest.

Territorials of 'A' Company, 5th Battalion, the Norfolk Regiment (T. F.), 'the Lynn Company', ready for church parade in front of the Corn Hall on the Tuesday Market Place, King's Lynn, c. 1912.

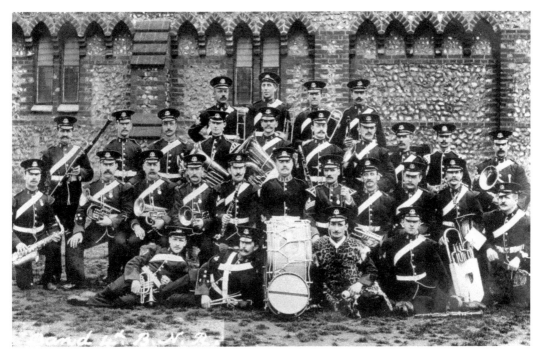

Band of 4th Battalion, the Norfolk Regiment (T. F.), c. 1912. In the early twentieth century most villages and towns had at least one band. Territorial Force bandmasters could have a choice of skilled musicians and competition was keen to have the honour of playing in the battalion band.

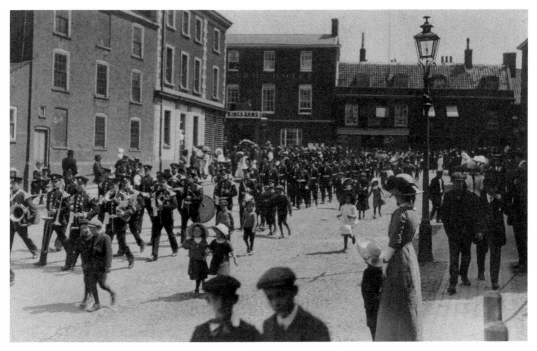

The band of 5th Battalion, the Norfolk Regiment, lead the battalion on parade down Church Street, East Dereham, to their headquarters, c. 1912.

Captain Frank Beck MVO (1861–1915). In 1908 Edward VII asked his Sandringham land agent, Frank Beck, to form a company for the newly created Territorial Force from men on the estate and the surrounding villages. He soon had over 100 men enlisted and E Company, 5th Battalion, the Norfolk Regiment (T. F.), was born. It remains the only company of Territorial Force soldiers to have been raised entirely on a British royal estate.

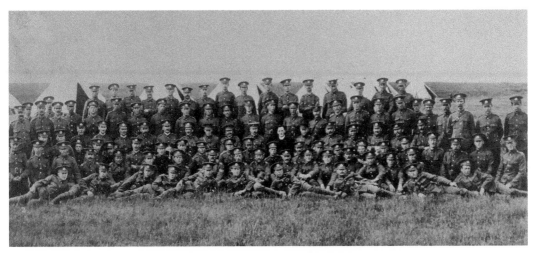

Officers and men of the Sandringham Company at Wolferton Camp, 19 June 1912.

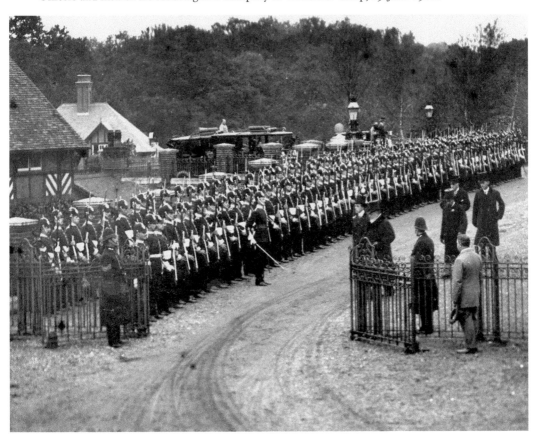

Before the creation of the Territorial Force there were the volunteers and royal visits to Sandringham were frequent in the decade before the First World War. Here a Guard of Honour provided by men of the 3rd Volunteer Battalion, the Norfolk Regiment, are inspected by Edward VII and Alphonso XII of Spain at Wolferton Station, 1905.

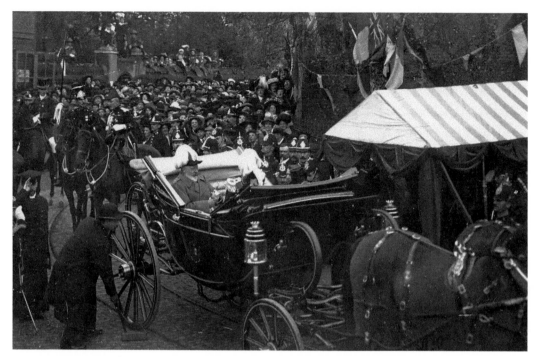

Edward VII outside the Chapel Field Drill Hall on his official visit to Norwich, 25 October 1909. During his visit he reviewed troops on Mousehold then presented colours to the 4th and 5th Battalions, the Norfolk Regiment (T. F.), and a guidon to the KORR Norfolk Yeomanry. He then travelled by carriage through streets lined with cheering people to the Chapel Field Drill Hall where he had lunch in the officers' mess.

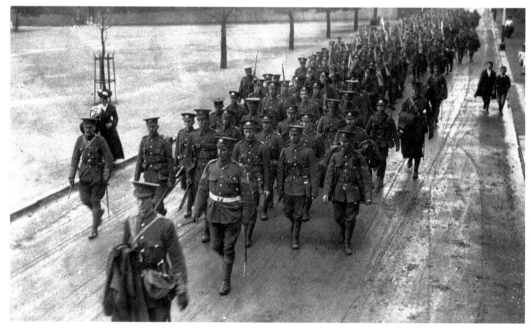

Officers and men of 5th Battalion, the Norfolk Regiment (T. F.), marching to camp, 1912.

CSM Bernard Sydney Parker, 5th Battalion, the Norfolk Regiment of Gorleston. He had originally joined the volunteers in 1898, served with the 5th Battalion from its creation in 1908 and went with the battalion to serve in Gallipoli in 1915 where he was wounded in action. One account described him as 'an ideal Territorial, full of zeal and enthusiasm for the work and a smart and hard-working NCO'.

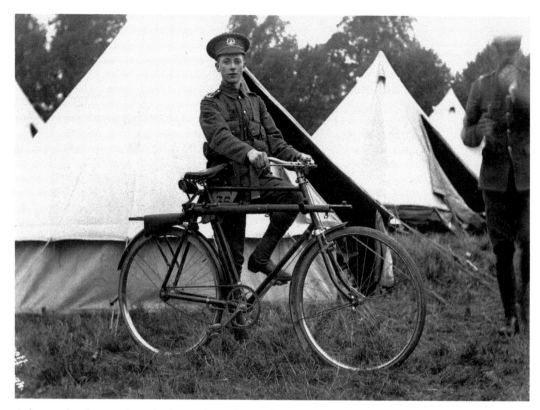

A fine study of a member of 6th Battalion, the Norfolk Regiment (Cyclists) (T. F.), in riding order, complete with his 'Long Lee' rifle in 1913. When the Territorial Force was created in 1908 the Norfolk Regiment had been granted the honour of raising one of the much-heralded eleven cyclist battalions (eight English, two Scottish and one Welsh) included in the scheme.

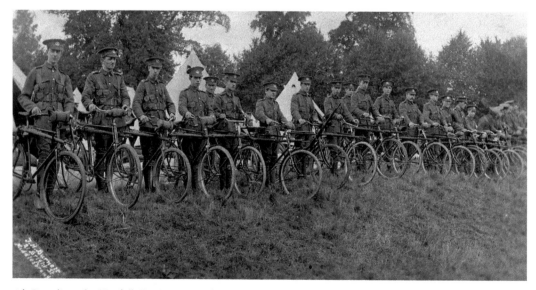

6th Battalion, the Norfolk Regiment (Cyclists) (T. F.), on parade at summer training camp, Boughton Park, Kettering, Northamptonshire, September 1913.

Territorial camp was also time for the soldiers to bond not only as soldiers but as friends. Here are some of the lads of 6th Battalion, the Norfolk Regiment (Cyclists) (T. F.), at Hunstanton Camp in 1911.

The Norwich City Boy's Brigade Company *c.* 1905. Many lads joined a variety of uniformed organisations that instilled a blend of Christian values and military skills such as marching, use of bugles and drums, and camps. Many of these lads patriotically joined up in the early years of the First World War.

Holt Boy Scout Troop *c.* 1914. The Boy Scout movement was organised to be the bicycle message carriers for Territorial Force troops in the event of them being mobilized for Home Service.

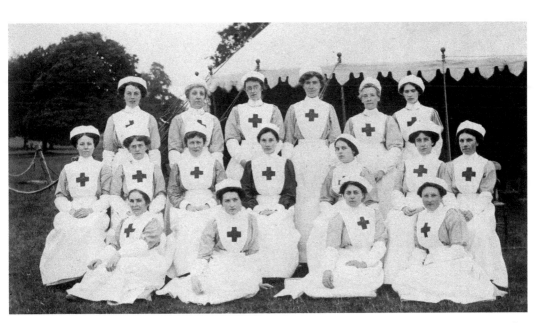

Members of the Sandringham Voluntary Aid Detachment of the British Red Cross Society *c.* 1912. After the creation of the Territorial Force in 1908, the War Office issued its Scheme for the Organisation of Voluntary Aid in England and Wales in the following year. In 1912 the scheme was expanded and VAD detachments were established across the county and the country as a whole, the idea being that they would provide the stretcher bearers and auxiliary hospitals for the Territorial Force units on Home Service in the event of them being mobilized for war.

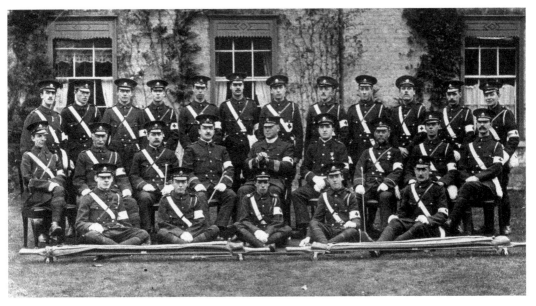

Members of the Gaywood & District Voluntary Aid Detachment Bearer Company, British Red Cross Society. There were no mixed Red Cross VAD units during the First World War but the male and female units would work together with men acting as stretcher bearers and orderlies while the women took the roles of nurses and domestics in the auxiliary war hospitals. Both men and women drove Red Cross and Order of St John ambulances.

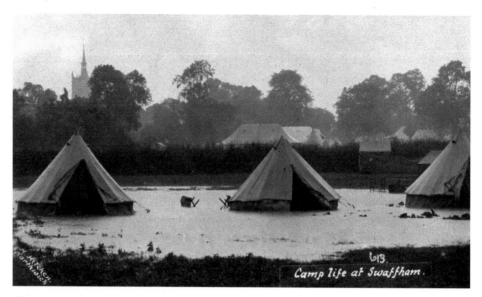

Camp life at Swaffham.

The last major manoeuvres to be carried out by the British Army before the outbreak of the First World War were planned to be staged across East Anglia in September 1912, but the whole thing almost didn't happen after extensive flooding occurred across the county in August 1912 and the advance party camps at Swaffham ended up under water.

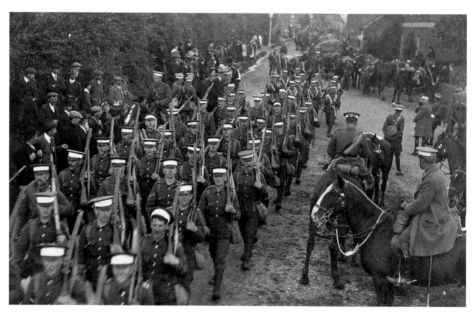

Men of 2nd Battalion, Coldstream Guards, draw crowds of fascinated locals at Swaffham during the 'Great Manoeuvres' in September 1912. The senario was the 'Red Enemy' from Aldershot Command under the command of Lieutenant General Sir Douglas Haig had made a landing between Wells and Hunstanton and were advancing towards London. It was the job of the 'Blue England' drawn from regular cavalry units, yeomanry, cyclists and troops from South and Eastern Commands under Lieutenant General Sir James Grierson to stop them. Haig ignored the value of aerial reconnaissance and it proved to be his undoing as his advancing troops were often checked and Grierson's 'Blue England' won the day.

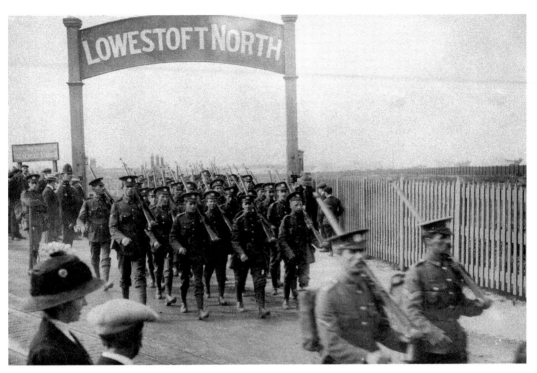

Norfolk Regiment Territorial soldiers marching out of Lowestoft North station en route to their summer camp, 1912.

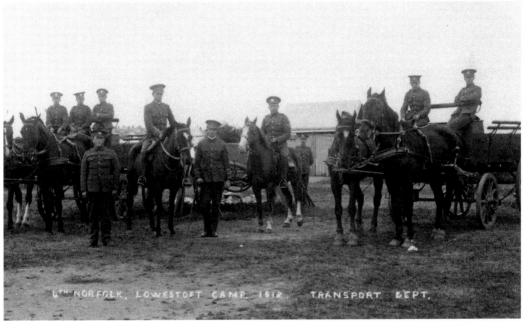

Transport Section, 4th Battalion, the Norfolk Regiment, at summer camp held at Lowestoft, Suffolk, in 1912. The pre-war armies of all nations still relied on horsepower to pull company transport and supply wagons. There were still less than 100 motorised vehicles in the British Army in 1914.

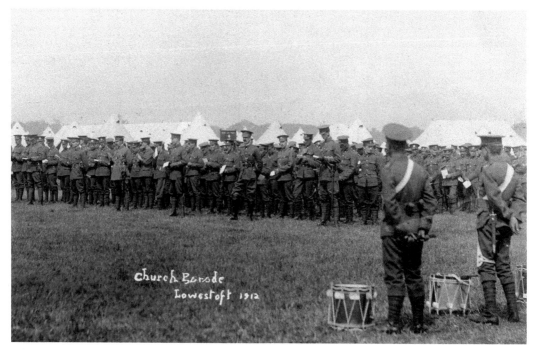

Church Parade
Lowestoft 1912

The men of the 4th and 5th Battalions, the Norfolk Regiment, on church parade with hymn sheets in their hands during their summer camp, Lowestoft, 1912.

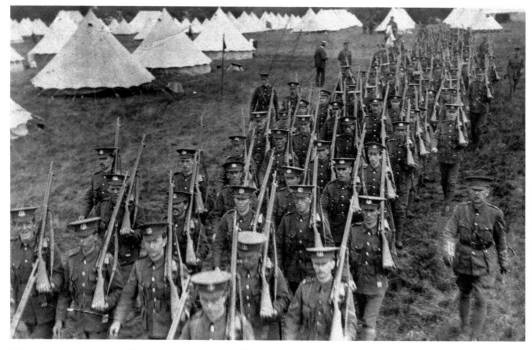

The weather in 1912 had been wet and when it did rain on summer camp for the boys of the Norfolk Regiment Territorial Force battalions. it was not long before well marched over areas of the camp became churned up, muddy ground.

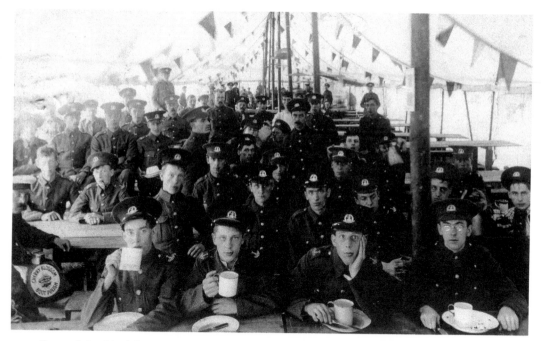

Boys of the Norfolk Regiment Territorial Force Battalions in the canteen tent at summer camp, Lowestoft, in 1912. The message on the reverse of this card sent by a 4th Battalion soldier to his girlfriend Helen L'Estrage on Knowsley Road back home in Norwich relates: 'It's absolutely washing us out this afternoon, raining in torrents, awful for camping.'

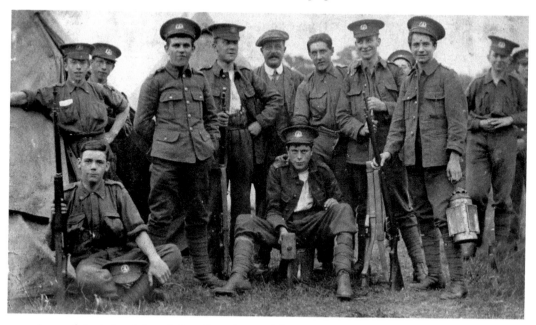

Some of the lads of the 5th Battalion, the Norfolk Regiment (T. F.), on camp, 1912. The extended family members, friends, neighbours and work colleagues joining and serving in their local territorials combined with the shared experience of training, hardships and good times promoted strong bonds of comradeship forged over many years before the outbreak of the First World War.

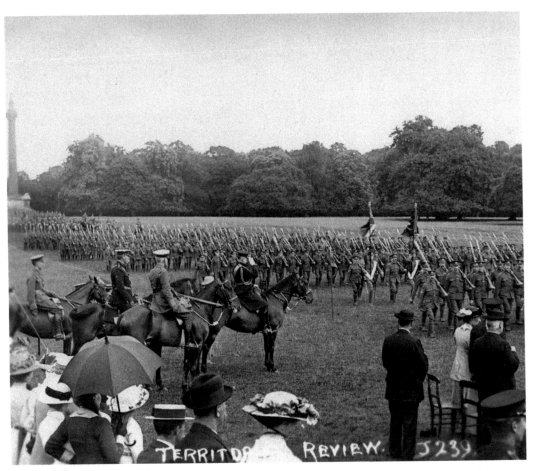

Men of the Norfolk and Suffolk Territorial Brigade march past the Earl of Leicester, president of the Country Territorial Association, who takes the salute with Major General E. S. Inglefield CB DSO, General Officer Commanding, East Anglian Division, Holkham, July 1914. This would prove to be the brigade's last great parade before the outbreak of war.

CHAPTER 2
Mobilization

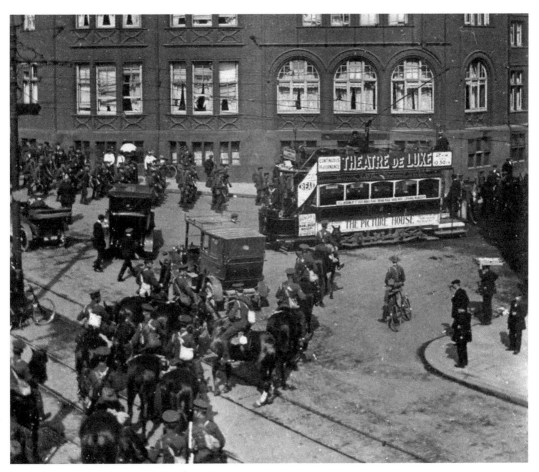

This view of Shirehall Plain captured the atmosphere of the day Norwich mobilized for war on 5 August 1914. War was declared at 1.00 p.m. on 4 August 1914 and orders to mobilize the Territorial Force were issued immediately afterwards, requesting soldiers to report at their battalion headquarters early the following morning. Once mustered and issued with ammunition some units were sent to their war stations immediately while others went into hastily requisitioned billets.

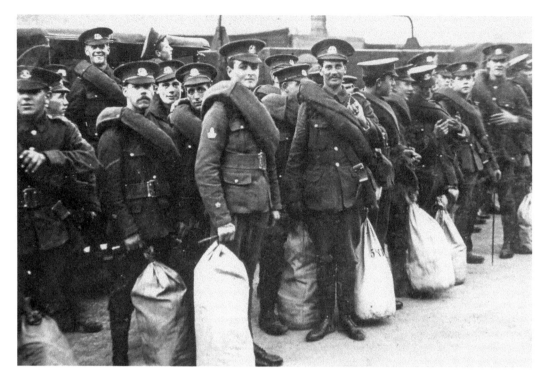

Soldiers of A Company, 5th Battalion, the Norfolk Regiment (T. F.), having been given a rousing send off as they marched out from St James's Hall in pouring rain assemble at King's Lynn railway station to catch the 12.30 p.m. train to their battalion headquarters at East Dereham, 5 August 1914.

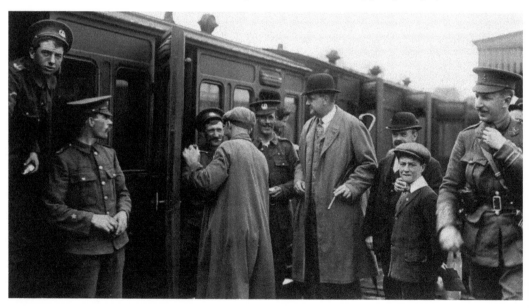

Time for a last few farewells to the Lynn Company, 5th Battalion, the Norfolk Regiment (T. F.), 5 August 1915. To the right of the picture is the smiling face of their popular company commander, Captain Arthur Pattrick. Little more than a year later, on 12 August 1915, Pattrick and over 300 soldiers of the battalion were left dead or wounded after an attack at Kuchuk Anafarta Ova in Gallipoli.

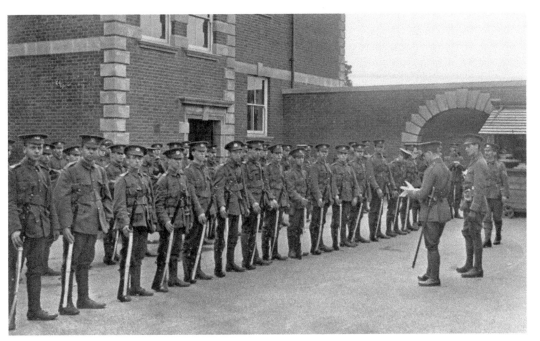

Roll call for men of the 4th Battalion, the Norfolk Regiment (T. F.), 5 August 1914. Having travelled from their Norwich and south Norfolk homes and reported to their battalion headquarters on Chapelfield, they are pictured shortly after their arrival at their commandeered billets at the City of Norwich Schools on Newmarket Road.

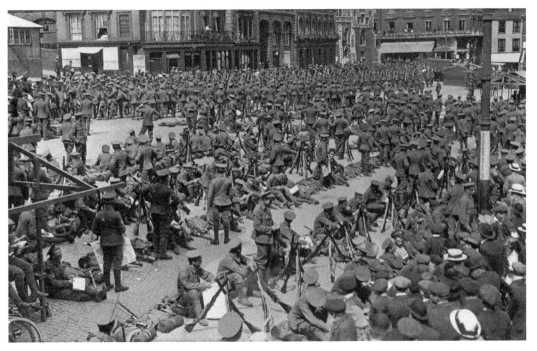

2nd Battalion, the Essex Regiment, are seen here resting in Norwich Market Place with rifles piled and full marching order webbing off, shortly after their arrival on 10 August 1914.

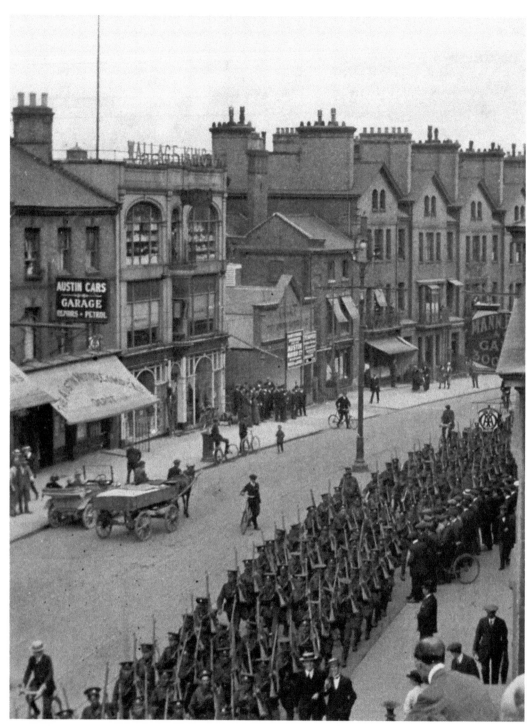

The first battalion of soldiers to be deployed to Norfolk after the outbreak of war were 2nd Battalion, the Essex Regiment. At that time spy scares were rife and the soldiers were initially sent to Cromer (8–9 August) in answer to the concerns that Cromer harboured a number of enemy agents. They were then sent to Norwich and are seen here marching up Prince of Wales Road on 10 August 1914.

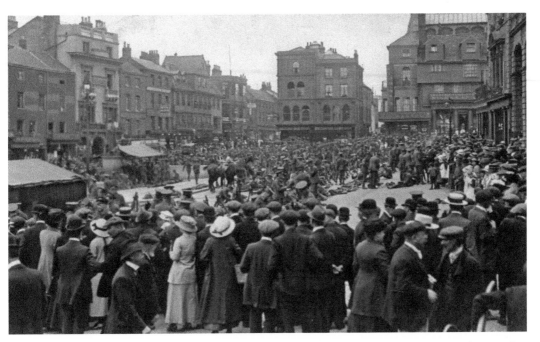

2nd Battalion, the Essex Regiment, had brought with them four German waiters they had arrested as 'illegal aliens' in Cromer and displayed them under a market stall as 'German spies'. (The stall is centre left by the statue of Wellington.) The sight drew thousands of curious spectators.

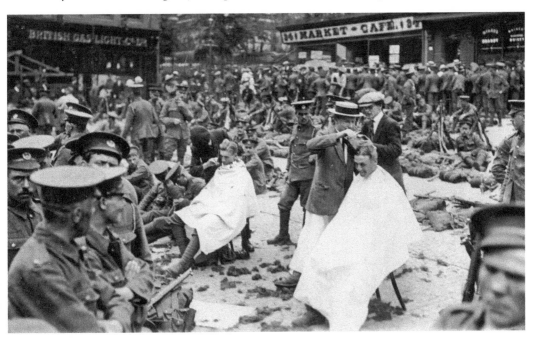

A number of the reservists who had been recalled to join 2nd Battalion, the Essex Regiment, needed proper military haircuts so enterprising Norwich barbers from shops along and near Gentlemen's Walk brought their chairs out into the Market Place and were happy to rectify the situation with good military haircuts – much to the amusement of their comrades and onlookers alike.

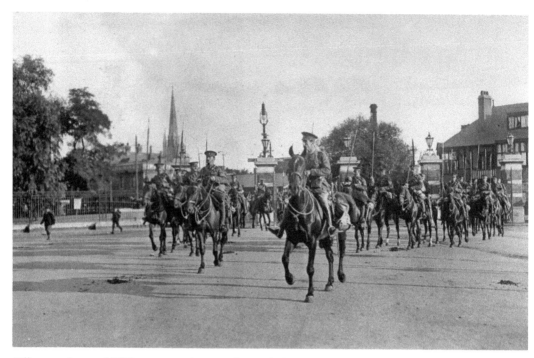

Officers and men of XII Lancers trotting into the yard of Thorpe Station on 16 August 1914 ready to load their horses into railway cattle trucks and the men into carriages and set out on their journey to the Western Front.

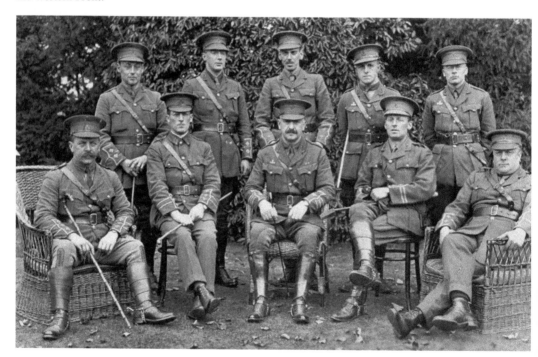

Lt-Col. James Bremner (seated centre) and the officers of 2nd East Anglian Field Ambulance, who had their headquarters on Bethel Street, Norwich, 1914.

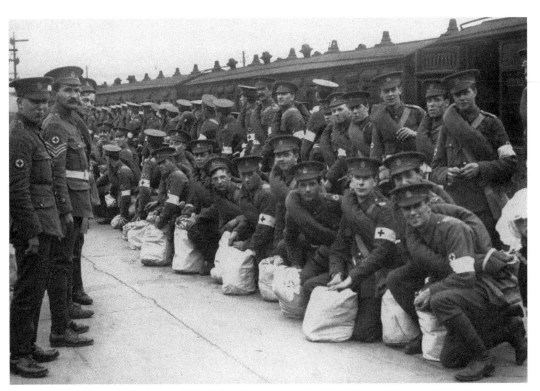

The men of 2nd East Anglian Field Ambulance ready to depart for their Home Service war stations from Norwich by train in 1914. They would see their first action at the Gallipoli landings in August 1915.

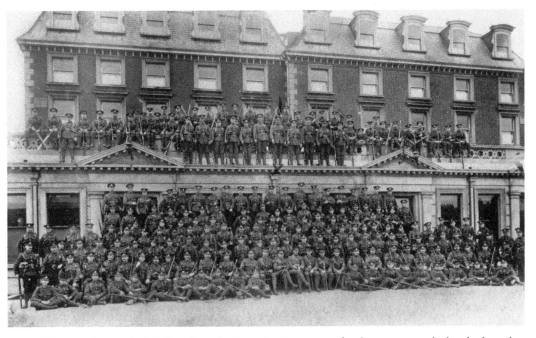

Officers and men of 2/4th Battalion, the Essex Regiment, pose for the camera on the hotel where they were billeted at Great Yarmouth in 1914.

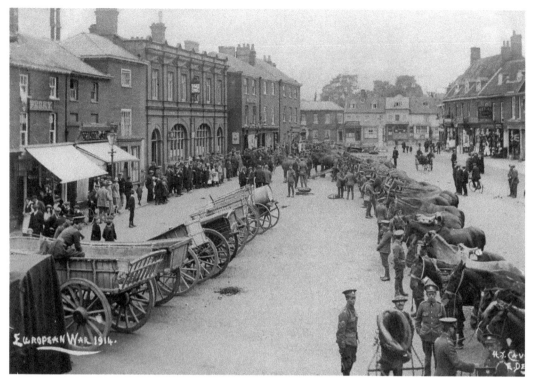

Horses, farm carts and wagons impressed for military service under the Army Act in East Dereham Market Place, August 1914.

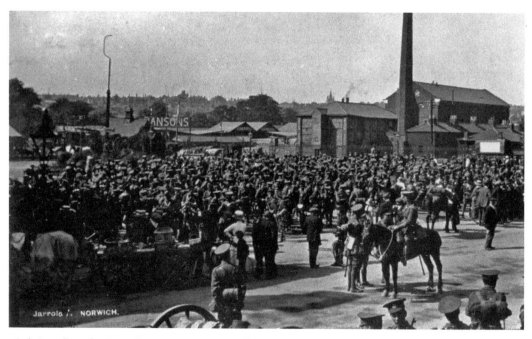

1/4th Battalion, the Essex Regiment (T. F.), soon followed their regular counterparts to Norwich and are seen here shortly after their arrival at City Station, 1914.

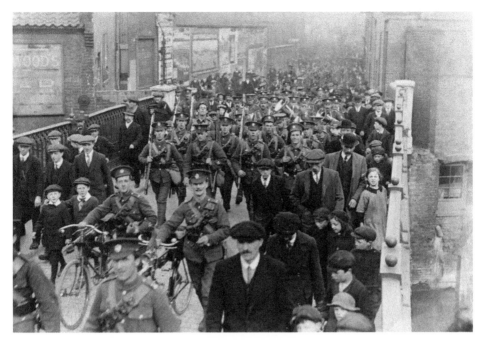

One of a series of photographs that captured the 1/4th Battalion, the Essex Regiment, as they crossed Duke Street bridge accompanied by hundreds of local well-wishers in 1914. The battalion left Norfolk in April 1915, became part of 54th (East Anglian) Division and landed at Sulva Bay, Gallipoli, in August 1915.

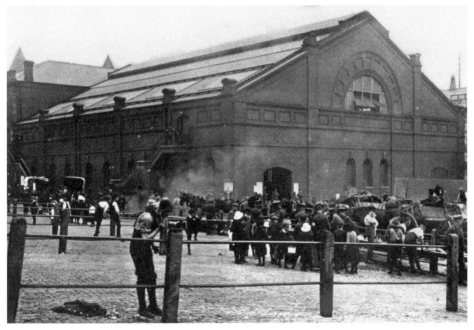

Soldiers with their battalion transport wagons and horses at the Agricultural Hall, Norwich, c. 1914. Troops occupied many of the warehouses, stores and even schools in Norwich city during the opening months of the war in 1914.

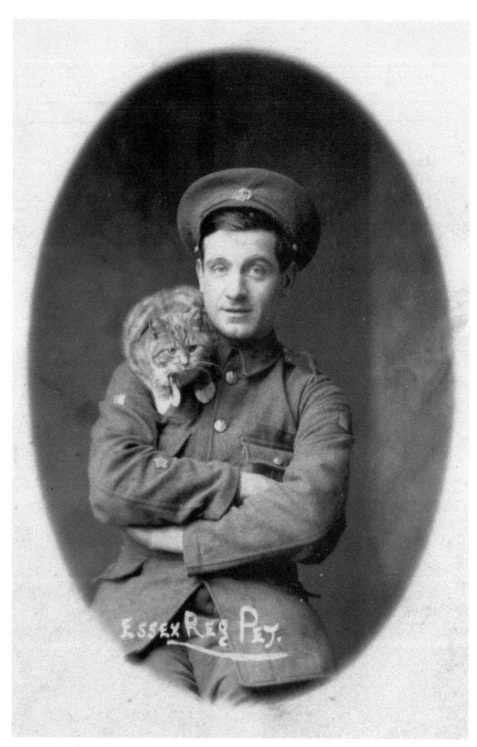

ESSEX REG PET.

A drummer of 1/4th Battalion, the Essex Regiment, with their pet cat, Norwich, 1914. Cats were essential for troops occupying old warehouses, stores and houses where troops were billeted because they helped to keep the vermin down.

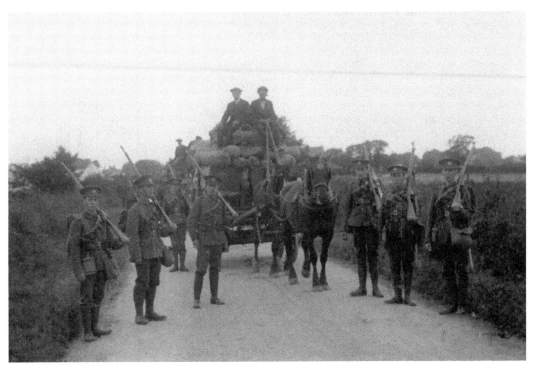

Civilian carts and drivers being used to transport the stores and equipment of 1/4th Battalion, the Essex Regiment, to their camp at Costessey Hall, 1914.

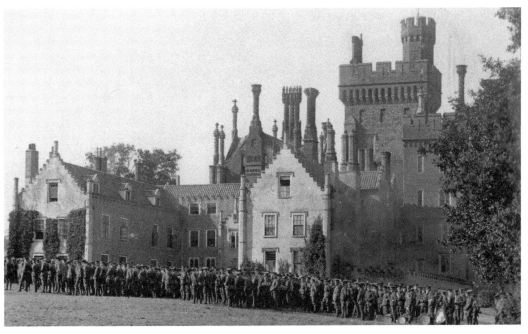

Battalion parade of 1/4th Battalion, the Essex Regiment (T. F.), at Costessey Hall, 1914. The hall had stood empty and the contents sold off in 1913 so the property was commandeered by the War Office as accommodation for troops in 1914.

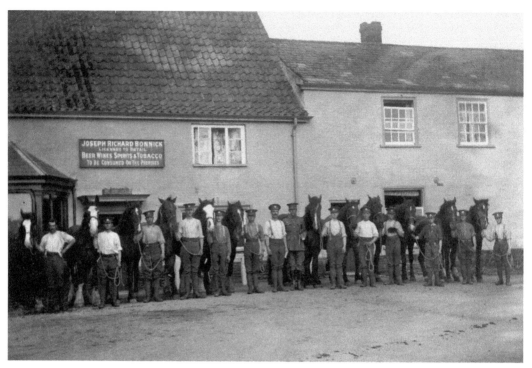

Members of the Essex Regiment transport section and the horses they had commandeered under the Army Act in front of the Black Swan, Horsham St Faiths, 1914.

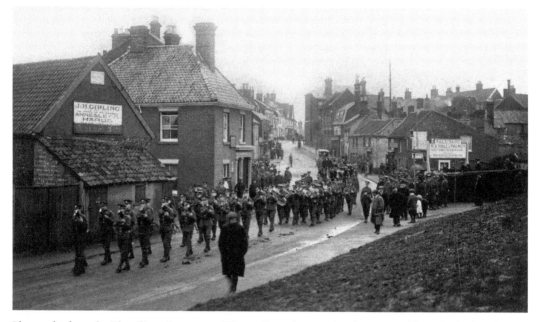

Photo of a funeral with military honours at Wymondham for a national reserve soldier who had died during a routine operation at the Norfolk & Norwich Hospital, November 1914. Soldiers of 1/4th Battalion, the Essex Regiment, were, by that time, billeted in the town and provided the Guard of Honour leading the cortege with reversed arms.

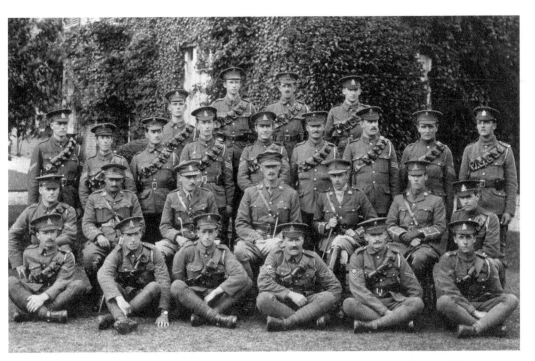

Officers and NCOs of A Squadron, 1/1st KORR Norfolk Yeomanry, which had its drill stations at Attlesborough, Long Stratton, Loddon, Diss and Harleston. It was photographed at their 'War Station' at Woodbridge, Suffolk, when part of the Home Defence forces in 1914.

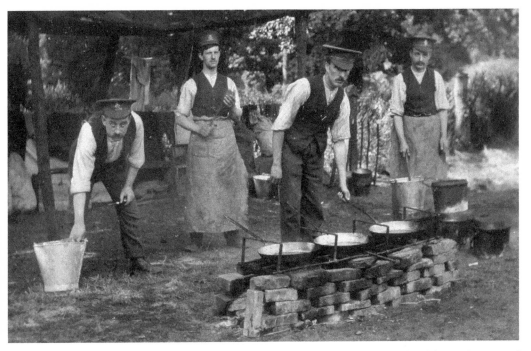

Field Kitchen complete with frying pans and steaming dixies ready to prepare breakfast at the camp of the 1/1st KORR Norfolk Yeomanry, Woodbridge, 1914.

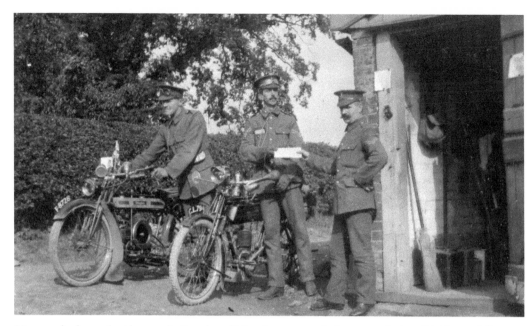

Motorcycle despatch riders ready 'for the off' by the camp orderly room of 1/1st KORR Norfolk Yeomanry, Woodbridge, 1914.

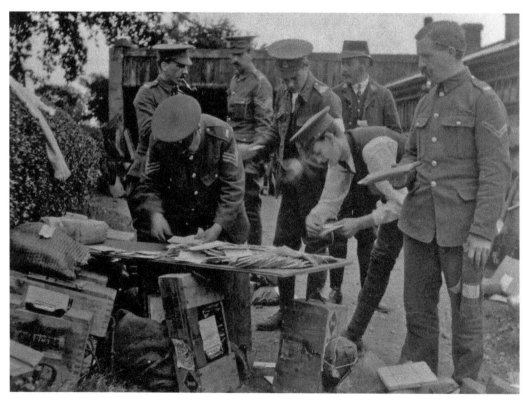

Post arriving (the postman himself is in the background) and being sorted on an improvised table supported by ammunition crates at the camp of the 1/1st KORR Norfolk Yeomanry, Woodbridge, 1914.

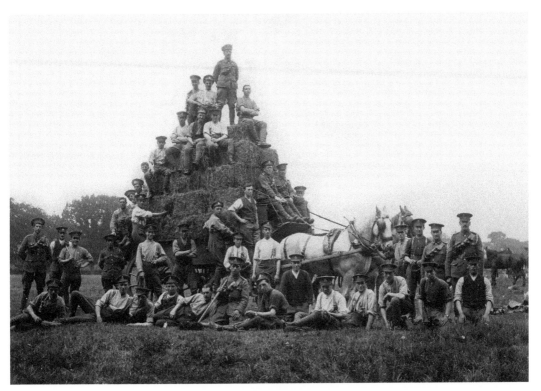

Men of the KORR Norfolk Yeomanry carting fodder for their horses, 1914. When war was declared the harvest was still to be gathered in on many farms so newly mobilized units were often drafted in to help. Many of the lads of the Norfolk Regiment were countrymen and had grown up helping with their local harvests so even if they were in a different area of the county, or even a different part of the country, harvest was harvest and it really did feel like home from home.

Your Country Needs You

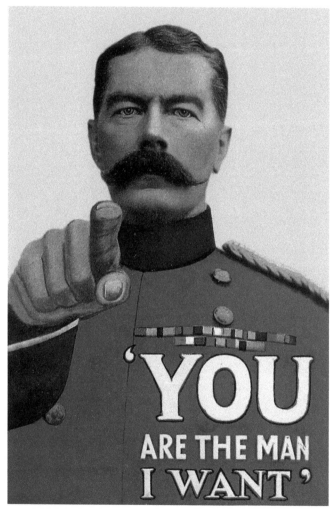

The famous Kitchener call to arms was first announced to the public within days of the outbreak of war and the doors of the recruiting offices opened for the first Kitchener volunteers on 11 August. Alfred Leete designed the iconic image of Kitchener with his pointing finger with the legend 'Your County Needs YOU' for the cover of the magazine *London Opinion*, published on 5 September 1914. It soon appeared in newspapers and magazines, posters and postcards and brought over half a million volunteers to the Army in the opening months of the war.

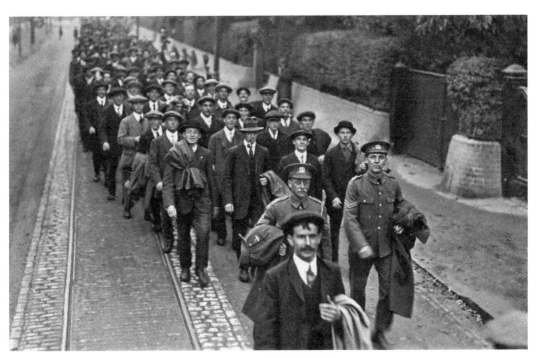

Recruits for the Norfolk Regiment marching down Newmarket Road, Norwich 1914. With thousands of men joining the army uniforms soon ran out and recruits spent their first weeks and even months of training wearing their own clothes and boots.

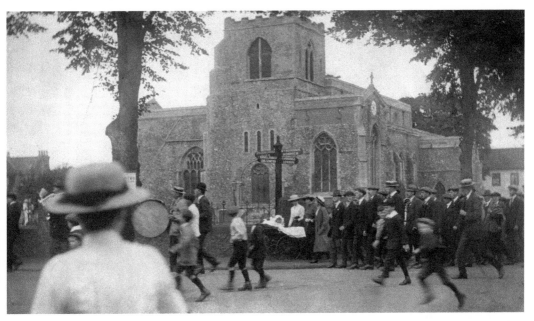

New recruits marching round the corner from Church Street onto Surrogate Street, Attleborough on their way to the station to the cheers and waves of local people as kids run along beside them, 1914. Volunteers for The Norfolk Regiment were encouraged to join up at recruiting meetings across the county and scenes like this were repeated across Britain as men from provincial towns marched away to enlist.

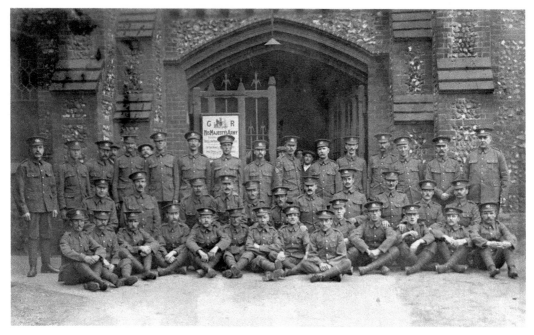

Reservists and recruits (the latter in civilian clothes looking through the entrance gate) for 4th Battalion, the Norfolk Regiment (T. F.), at the Chapel Field Drill Hall, Norwich 1914.

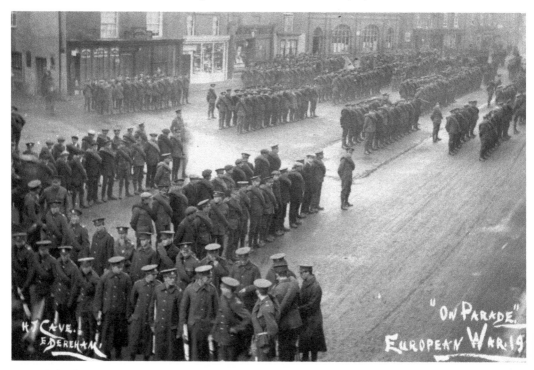

One of the first parades of 5th Battalion, the Norfolk Regiment (T. F.) (Reserve), East Dereham Market Place, October 1914. The reserve battalion was raised with the intention of supplying men for 5th Battalion as and when they were required.

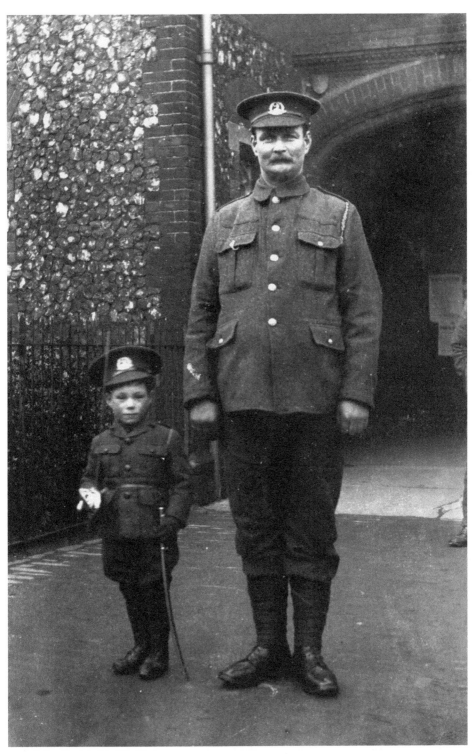

A proud soldier of 5th Battalion, the Norfolk Regiment, with a young battalion mascot outside the York Road Drill Hall, Great Yarmouth, 1914.

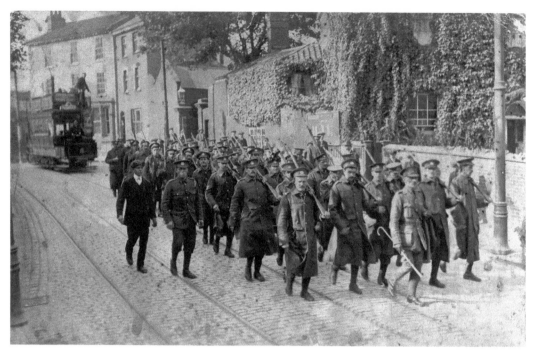

Recruits of 4th Battalion, the Norfolk Regiment (T. F.) (Reserve), on a training march through Norwich, 1914. (Courtesy of Raymond Rogers)

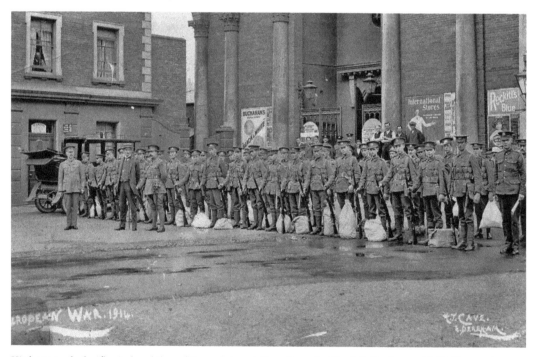

Kit bags packed, rifles in hand the soldiers of the 5th Battalion, the Norfolk Regiment (T. F.) (Reserve), on parade in front of East Dereham Corn Hall, 1914. Those without full uniforms can just be spotted behind the back row on the steps of the Corn Hall.

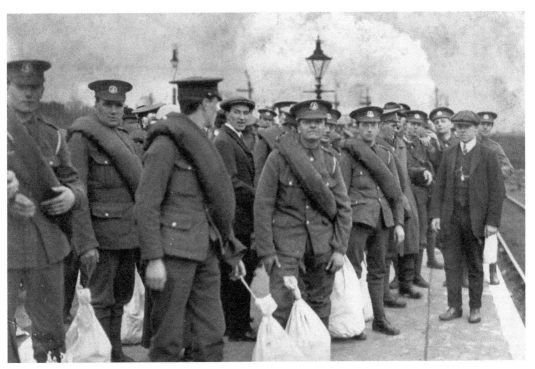

Soldiers of 4th Battalion, the Norfolk Regiment (T. F.) (Reserve), ready to leave for Peterborough from Thorpe Station, Norwich, 1914. (Courtesy of Raymond Rogers)

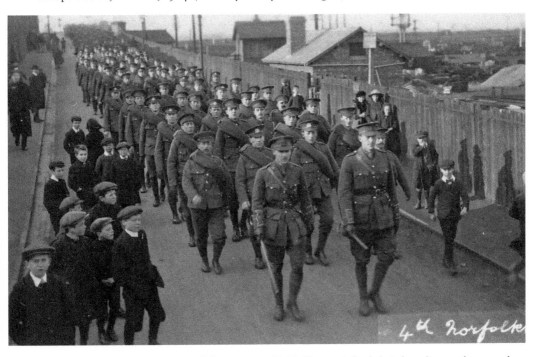

Officers of 4th Battalion, the Norfolk Regiment (T. F.) (Reserve), lead their battalion as they march to their camp from the railway station at Peterborough, December 1914.

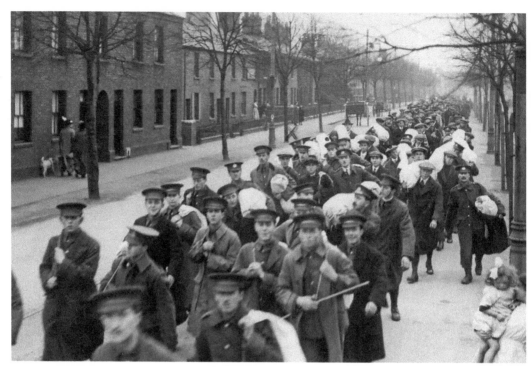

Men of the 5th Battlion, the Norfolk Regiment (T. F.) (Reserve), shortly after their arrival at Peterborough, December 1914. Some of them are still without complete uniforms.

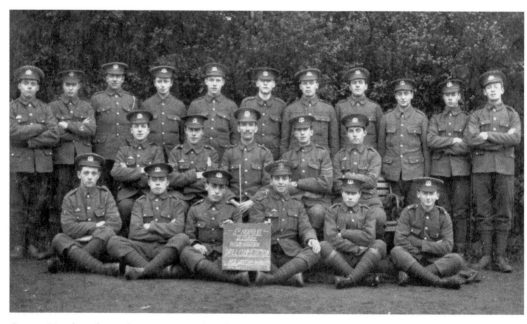

Competition has always been encouraged in the Army, be it sports, shooting or drill, because it keeps soldiers healthy, keen and fosters teamwork. Here are No. 3 Section, D Company, 2/5th Battalion, the Norfolk Regiment (T. F.), winners of the D Company, inter-section drill competition, Peterborough Recreation Ground, 1915.

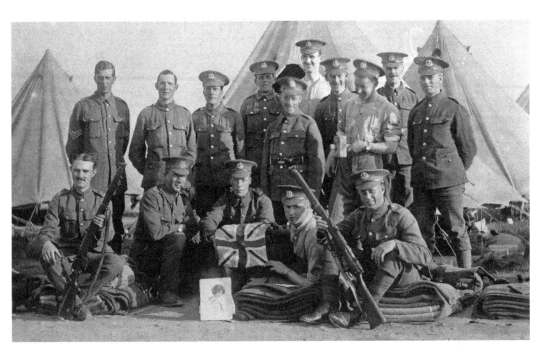

Soldiers of 4th Battalion, the Norfolk Regiment, at training camp, 1915. The men at the front are sat on the blankets that would make their bedding. At some points during shortages and heavy recruitment as many as twenty men were known to share a single bell tent sleeping side by side with their feet to the pole in the centre of the tent.

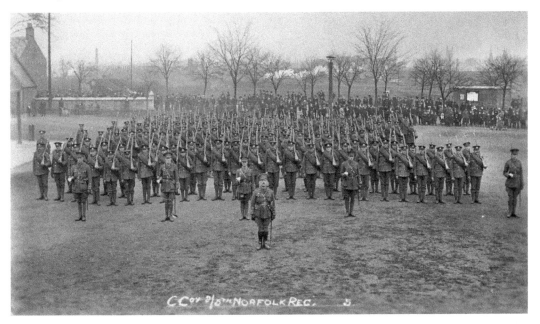

Full parade of C Company, 2/5th Battalion, the Norfolk Regiment, Peterborough, January 1915. The Norfolk Regiment Territorial Force Infantry battalions were numbered 1/4th and 1/5th for the first line battalions and their reserve or second line battalions were designated 2/4th and 2/5th. There were also 3/4th and 3/5th Battalions formed early in 1915.

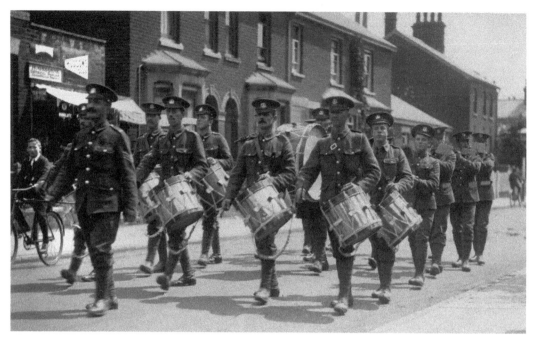

The drums of 10th (Reserve) Battalion, the Norfolk Regiment Service Battalion, Rochester, Kent, *c.* 1915. One way to literally drum up interest in joining the Army for hundreds of years was to march into towns and villages with the battalion drums. This also helped to build bridges with local communities near where soldiers were encamped. During the First World War it was still common practice for the drums to lead route marches too.

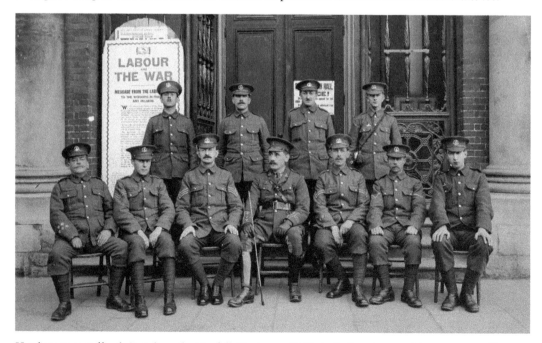

Headquarters staff, 5th Battalion, the Norfolk Regiment (T. F.), including the recruiting sergeant with rosette in his hat (seated centre left, with his immaculately shone boots) in front of the entrance to the Corn Hall, East Dereham, 1915.

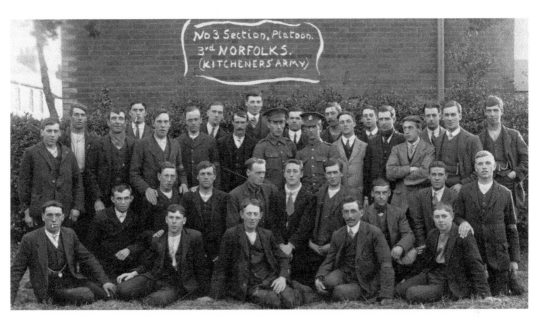

No. 3 Section Platoon, 3rd Norfolk Battalion of Kitchener's Army, which, when up to strength, became 9th (Service) Battalion, the Norfolk Regiment. On establishment each battalion contained just over 1,000 men. By September 1914 a total of three battalions for Kitchener's Army had been raised in Norwich from city and county men. These became the 7th, 8th and 9th (Service) Battalions. By September 1915 all three Norfolk Regiment Service battalions were on active service in the trenches on the Western Front.

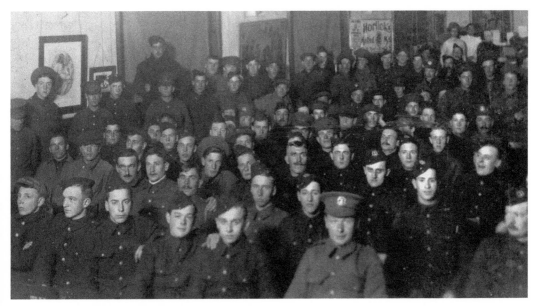

Men of the Norfolk Regiment Service battalions ready for a soldiers concert, 1914. The uniform many of the men are wearing was known as the 'Kitchener blue', which comprised a side-hat, jacket and trousers that had been sourced from extant uniform stocks held by the likes of the HM Prisons, lunatic asylums and even the post office and hastily dyed blue. Shapeless and not colour fast, the uniforms even turned the recruits skin blue if the wearer sweated or got wet.

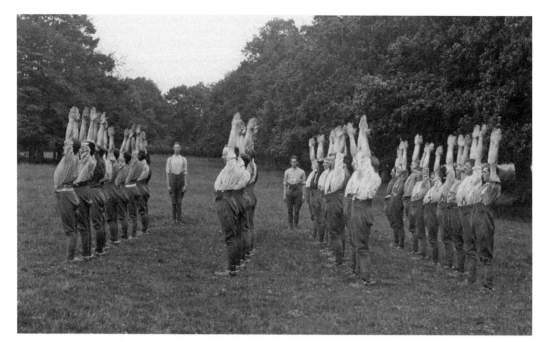

Soldiers of the Norfolk Yeomanry having their daily Physical Training (P. T.) session in 1914. Swedish drill was very much in vogue, the standard method taught in schools and a key feature of the training of new recruits to develop and optimise their physiques for military service.

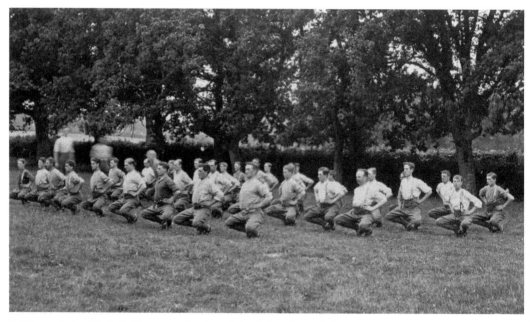

Soldiers of the Norfolk Yeomanry having their daily Physical Training (P. T.) session in 1914. Awareness of the need for fitness is part of all our lives in the modern world but it was only from the late nineteenth century that concerns had been raised and attention moved to addressing the health of our nation's children and fighting forces by the introduction of physical exercise as part of the school curriculum and military training.

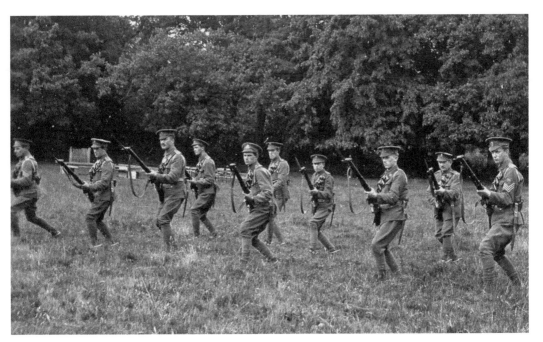

Soldiers of the Norfolk Yeomanry practising the 'On Guard' opening stance of bayonet fighting, 1914. Training with rifle with fixed bayonet was intended to harden recruits and give them the metal to become fighting men.

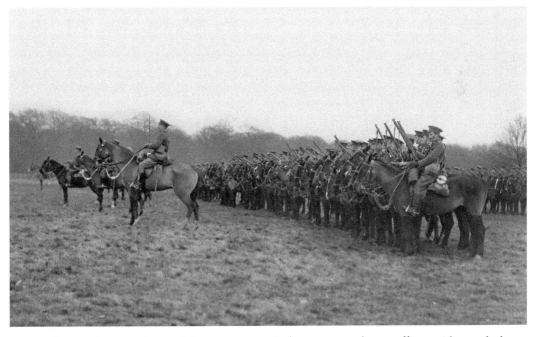

Officers and men of the Norfolk Yeomanry ready for a practice charge, officers with swords drawn and men with rifles at the ready, 1914. Although cavalry was still very much part of the order of battle in the First World War, the need for infantry was far greater and the Norfolk Yeomanry went to war dismounted.

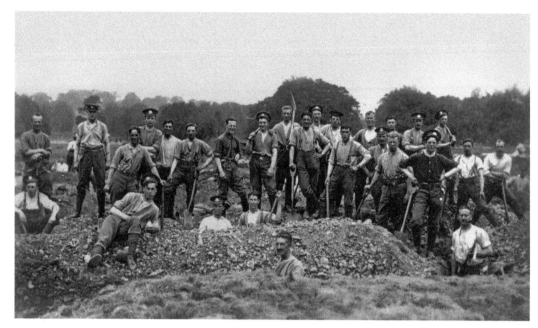

Soldiers of a Norfolk Regiment Territorial Force battalion digging practice trenches, 1914. Trench digging was a regular feature of manoeuvres where men would practice fire and movement, then dig in, defend their position or carry out attacks from their trench. After a long day (and frequently an overnight stay manning the trench) they would fill the trench in again then march back to camp. A number of trench networks were also dug by troops in the county and regularly used for training purposes and as invasion defences.

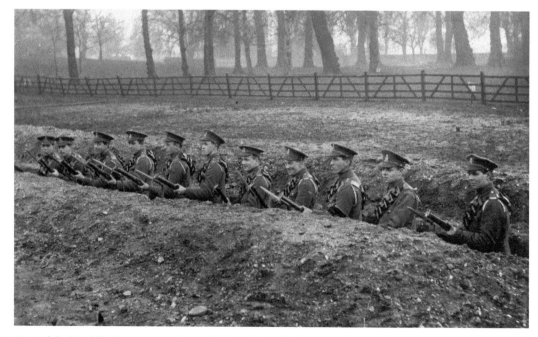

Men of the Norfolk Yeomanry ready to climb out from their practice trench to engage the enemy with fixed bayonets, 1914.

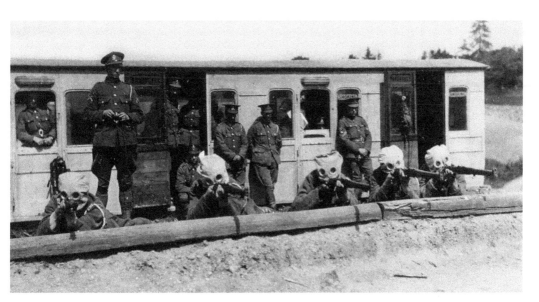

Men of the Norfolk Yeomanry on the rifle range familiarising themselves with firing their SMLE rifles wearing anti-gas hoods at their training camp, 1915. Their training and the war to date led the men of the Norfolk Yeomanry to expect they would serve on the Western Front but they were deployed to Gallipoli in 1915, then Egypt and Palestine, only being sent to the Western Front in 1918.

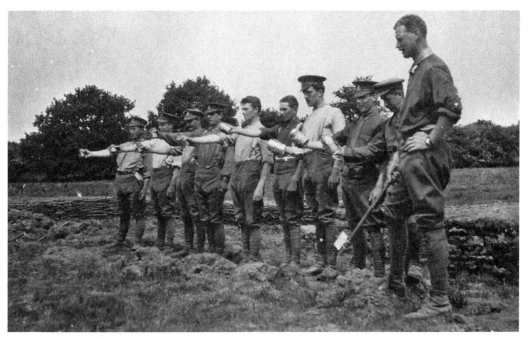

The Bombing Officer (on right with sticking in hand) and soldiers of the Norfolk Yeomanry at bombing practice, 1915. One device that was to prove very useful in trench warfare wherever men were serving was the hand grenade. The ones held by the soldiers in this photograph are improvised from cordite emptied from bullets, small stones and items of metal such as tacks or nails cased in tin cans and exploded by a detonator with a manually ignited fuse. One of the tinned foods supplied for troops was Tickler's Jam and these grenades were rapidly nicknamed 'Tickler's Artillery'.

Soldiers from 1/4th Battalion, the Norfolk Regiment (T. F.) during visual signal training with semaphore flags, 1914. During training all soldiers would be shown the basics in such skills as bombing, marksmanship, machine gunning, signalling or cooking and those who showed the greatest aptitude or skill in these areas would be put forward to attend specialist courses to qualify in those proficiencies.

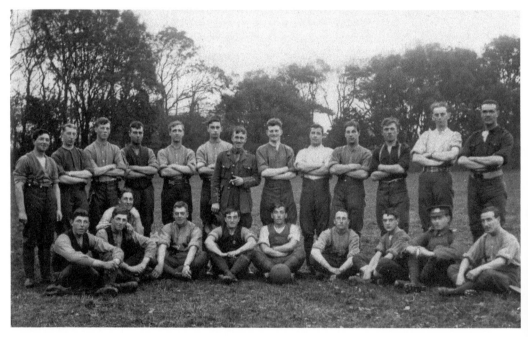

Captain Sidney Dewing (standing centre) and soldiers of 1/6th Battalion, the Norfolk Regiment (T. F.) (Cyclists), after an inter-company football match in 1914. They had no football kit to play in so it was usually just jackets off and on with the game.

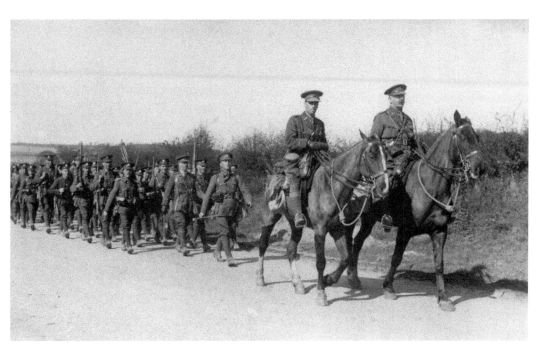

Norfolk Regiment soldiers on a route march during training, 1915. They have their full uniforms and full marching kit. Mounted on their horses are the company commander (right) and his Second in Command. They are followed on foot by the company sergeant major followed by the junior company officer and NCOs and men. Route marches in full marching order covering 15–25 miles in a day remained a twice weekly feature for all infantry battalions in training.

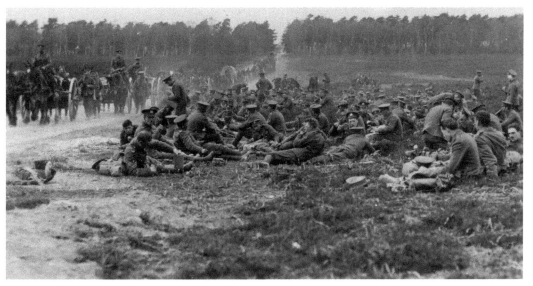

Men of 8th (Service) Battalion on manoeuvres at Hollesley Bay, Suffolk, 1915. As training progressed battalions were brigaded with battalions from other regiments to form the 53rd Infantry Brigade and they began training and working together on larger-scale manoeuvres. Their brigade would form part of the 18th (Eastern) Division that fought with distinction on the Western Front, notably on the First Day of the Somme.

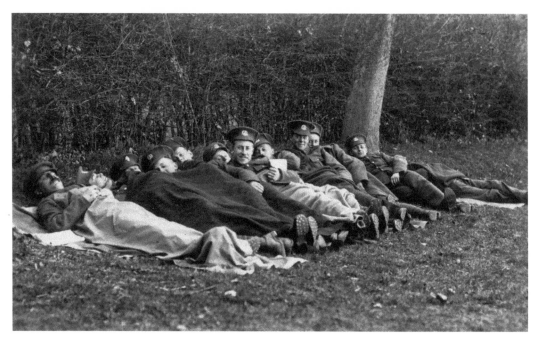

Men of 8th (Service) Battalion, the Norfolk Regiment, and a few others from their Brigade that fell out to rest on account of sore feet during the manoeuvres at Hollesley Bay, 1915.

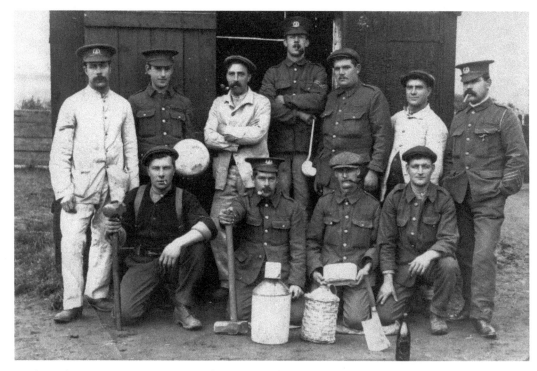

Cooks and quartermaster's stores men for a service battalion of the Norfolk Regiment, with the quartermaster himself on the right of the photograph, 1914. A number of them still have incomplete uniforms and are wearing their civilian caps.

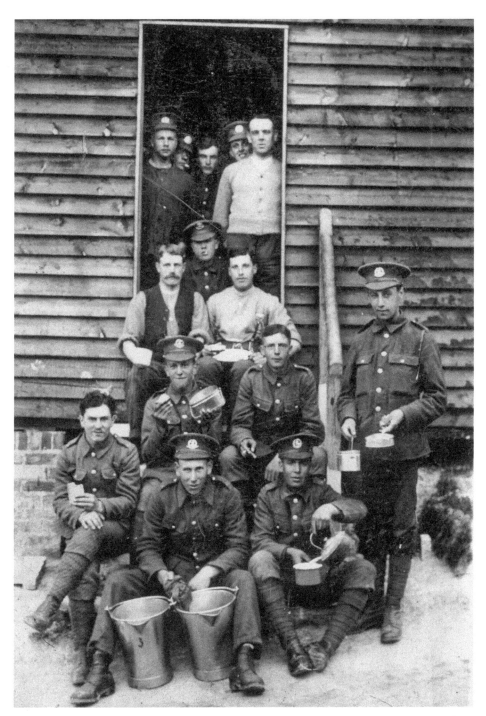

Norfolk Regiment lads sat on the steps of their barrack hut during training *c.* 1915. The soldier standing on the right holds the mess tins typically carried by every infantry soldier during the First World War. The lid in his left hand could be used for frying and the tin in his right hand could be used for boiling water for tea or heating up Tommy stew – a confection consisting of hard tack biscuit broken up in water and boiled with corned beef (bully beef) and an OXO cube.

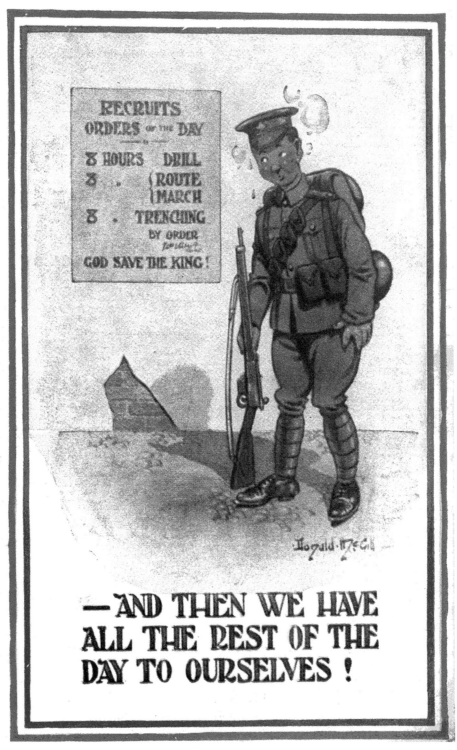

This comic card by popular pre-war saucy seaside comic postcard artist Donald McGill would have certainly struck a chord with any soldier in training.

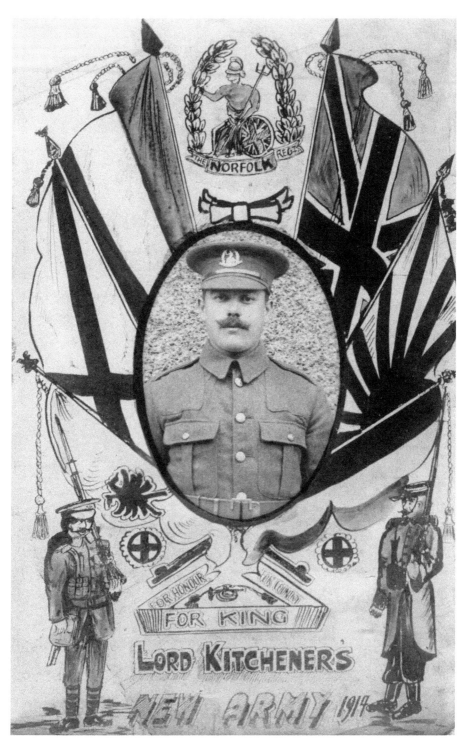

One of many versions of soldier portrait postcards that has a studio portrait of the soldier himself with either artist- or photographer-drawn patriotic surrounds produced during the First World War. This example dates from 1914 and shows a soldier from a Norfolk Regiment Kitchener battalion.

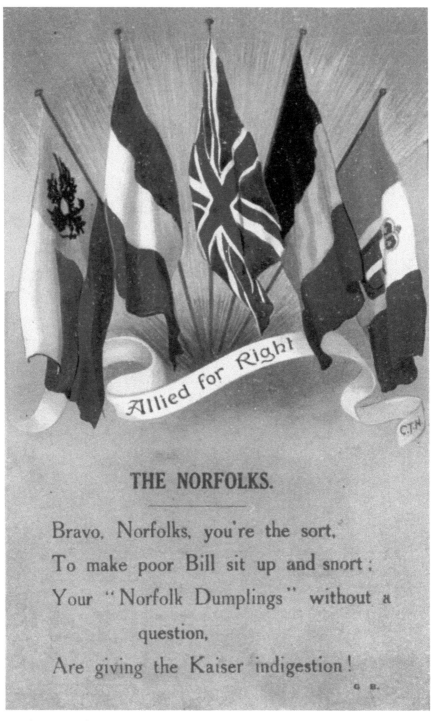

THE NORFOLKS.

Bravo, Norfolks, you're the sort,
To make poor Bill sit up and snort ;
Your " Norfolk Dumplings " without a
question,
Are giving the Kaiser indigestion !

G B.

Another series of greetings cards produced in colour during the First World War showed the flags of the allies and had variations that featured verses for every regiment and corps of the British Army. This version for the Norfolk Regiment is my personal favourite and one of the first cards I bought almost forty years ago.

**If der Norfolks
haf gone by, den I kan kom out.**

The most popular greetings cards, however, mocked the Kaiser and German soldiers in image and language. These too were often over printed with a huge variety of regiments.

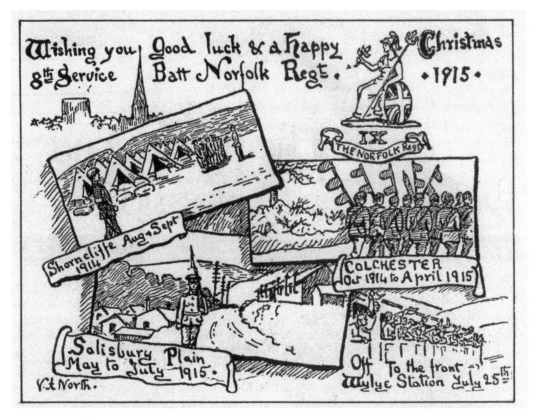

Christmas card charting the journey of 8th (Service) Battalion, the Norfolk Regiment, through training to departure to the front drawn by battalion officer Captain V. A. North.

Officers and men of 1/4th Battalion, the Norfolk Regiment, at a roadside halt during a route march, Watford, 1915. Good leadership includes a bit of good humour and it's lovely to see the officers and men having a lark about in front of the camera.

Bugler Gilbert, Earl of Thetford, photographed when serving in 6th Battalion, the Norfolk Regiment, 1914. He is proudly wearing his Imperial Service badge above his right breast pocket, which denoted he had volunteered for overseas service.

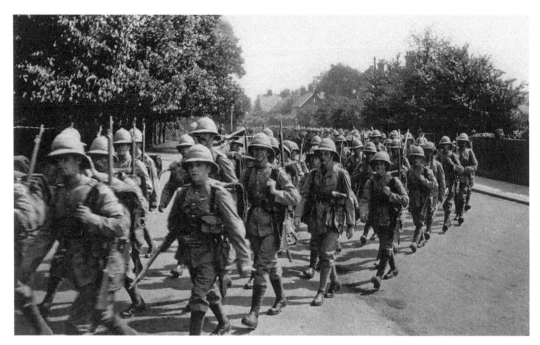

Officers and men of 1/5th Battalion, the Norfolk Regiment, marching in their foreign service kit, Watford, 1915. Fearing they had been sidelined for garrison duty out in India, it was only after they had steamed out from Liverpool aboard the SS *Aquitania* that the majority of men were told their destination was to be Gallipoli.

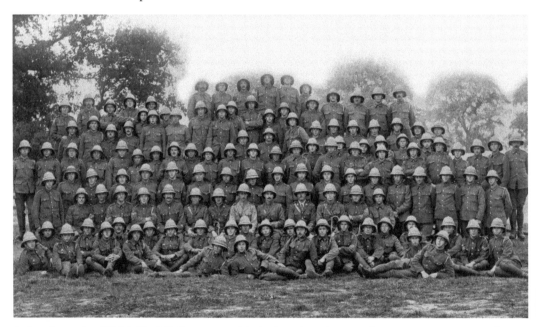

A Squadron, 1/1st KORR Norfolk Yeomanry, with the Squadron Commander Captain J. Dawson Paul (centre in full foreign service uniform) shortly before their departure for Gallipoli in 1915. Although not the first in, the last man to leave the shores of the Gallipoli during the evacuation of 20 December 1915 was Sgt Robert Pymar of the Norfolk Yeomanry.

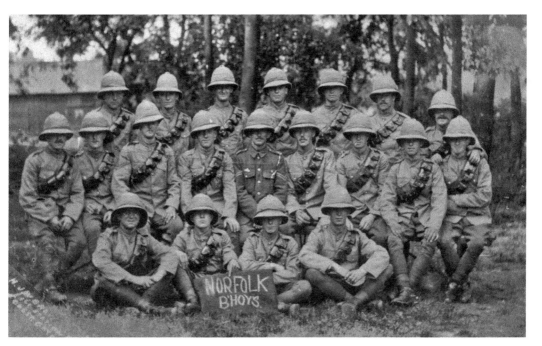

Norfolk Territorial Gunners on their way to the Middle East, 1915. The word 'B'hoys' often appeared on postcards and boards held in front of soldiers during the First World War and is derived from the popular Music Hall Irish pronunciation of the word 'Boy', especially when applied to sparky young men about town who were not afraid of a fight. In a similar vein one of the most popular songs of the early war years was about 'Gilbert the Filbert – the K'nut with a K', which also appeared on the chalkboards in front of group photos of British soldiers.

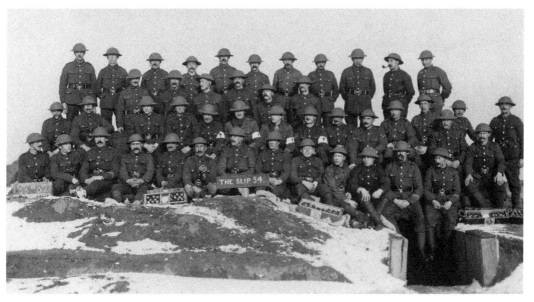

Mills bombing instructors (wearing arm bands, seated centre) and soldiers attending the course held in the entrenchments near Weybourne, Winter 1917. Each crate contained six grenades and the round tin in the centre compartment of the crate contained the detonators.

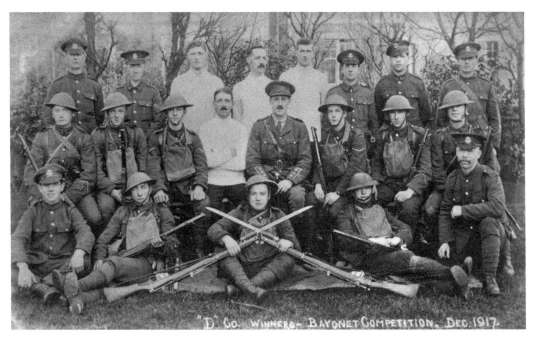

'D' Company team from 32nd Battalion, the Middlesex Regiment (T. F.), winners of the bayonet fencing championship, Gorleston, December 1917.

CHAPTER 4

At Sea and in the Air

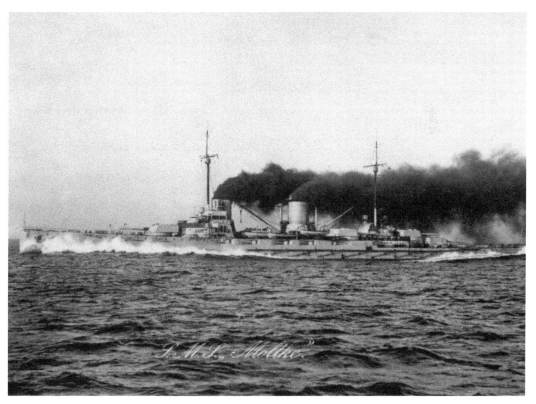

SMS *Moltke*, one of the four battle cruisers of 1st Scouting Group of the Imperial German Navy, with the light cruisers of the 2nd Scouting Group that attempted to shell Norfolk coastal towns of Great Yarmouth and Gorleston, shortly after 7.00 a.m. on the morning of 3 November 1914. This was the first time German battleships had shelled Britain.

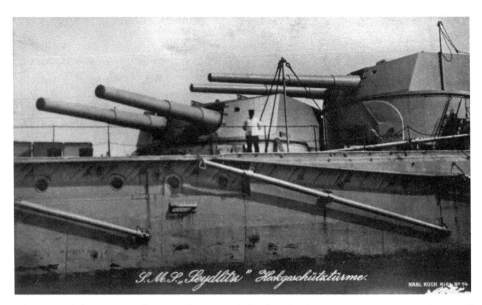

The guns of the SMS *Seydlitz*, another one of the four battle cruisers 1st Scouting Group of the Imperial German Navy that shelled Great Yarmouth and Gorleston on 3 November 1914. Fortunately it was a misty morning, the enemy ships appeared to be over the horizon and most of the shells fell just short of the beaches or into the water. The northern coastal resorts of Scarborough, Whitby and Hartlepool would not be so fortunate when they were bombarded in December 1914 and hundreds were killed or injured. German battleships would return to shell Great Yarmouth on another two occasions in 1916 and 1918 when several houses and businesses were badly damaged and a number of people were killed or injured.

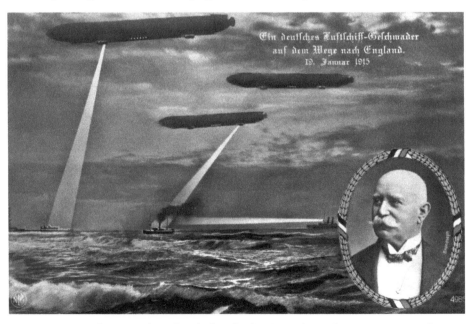

German propaganda postcard produced after the first Zeppelin raid on Britain on 19 January 1915. Only two of the three Zeppelins that set out made it over British soil and dropped bombs on a number of locations along the Norfolk coast.

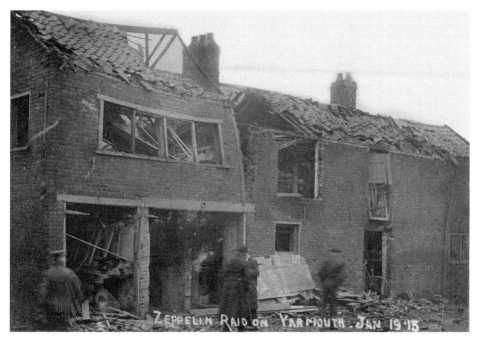

The passage entrance to Drake's Buildings and the wrecked premises of J. E. Pestell, builder and undertaker, St. Peter's Plain, Great Yarmouth, the morning after the Zeppelin air raid of 19 January 1915. Zeppelin L3 under the command of Kptlt Johann Fritz had found its targets first. Local cobbler Samuel Smith was standing at the entrance of the passageway watching the Zeppelin when it dropped the bomb that caused the damage here, he was killed instantly.

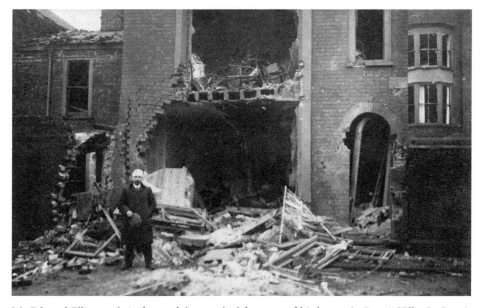

Mr Edward Ellis stands in front of the wrecked frontage of his home, St. Peter's Villa, St. Peter's Plain, Great Yarmouth, the morning after the air raid on 19 January 1915. His head was injured when his back door was blown of its hinges and fell on top of him, as did the kitchen window resulting in a painful gash to his knee.

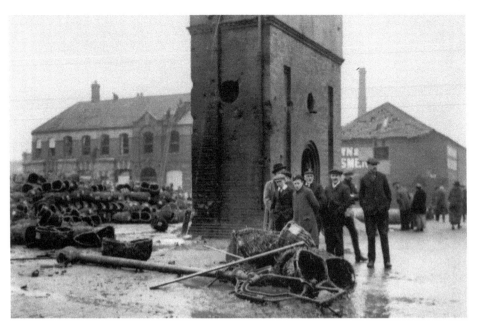

Bomb damage to the swill ground at the back of the Fish Wharf, Great Yarmouth, after the air raid on 19 January 1915. Note the flying shrapnel damage to the water tower and the repairs being carried out to the buildings in the background.

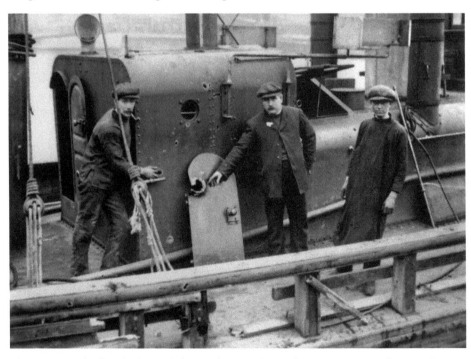

There were twelve bombs dropped during the Zeppelin raid on Great Yarmouth on 19 January 1915. The penultimate bomb was a high explosive that fell by the river sending shrapnel flying into Mr Harry Eastick's steam drifter, *Piscatorial*, blowing a hole in the quarter, 'started' the timbers and blew the rigging wire out.

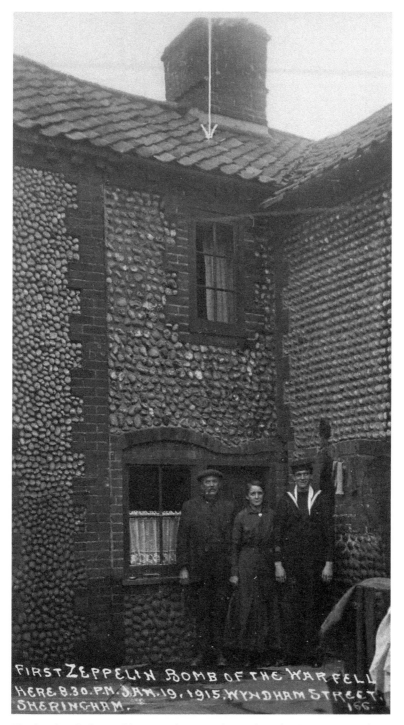

FIRST ZEPPELIN BOMB OF THE WAR FELL
HERE 8.30. P.M. JAN. 19, 1915. WYNDHAM STREET,
SHERINGHAM.
166.

The first bomb dropped by Zeppelin L4 under Kptlt Count Magnus von Platen Hallermund, the second Zeppelin that made landfall on 19 January 1915, fell upon the home of Robert Smith and his family at Whitehall Yard off Windham Street, Sheringham. Fortunately it did not explode.

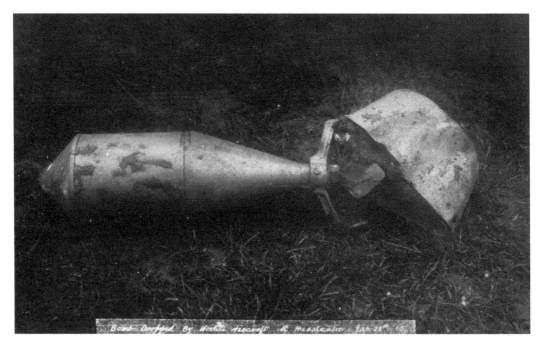

Unexploded high explosive bomb that was dropped by Zeppelin L4 near the centre of a field on the high road leading from Old Hunstanton to New Hunstanton, 19 January 1915. Concerns were raised that the Zeppelin raiders had intelligence and targeted the secret wireless interception station located around 300 yards away.

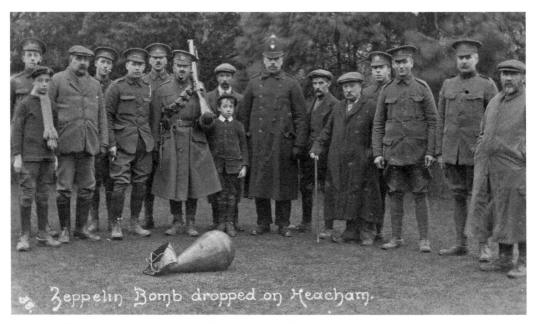

Unexploded high explosive bomb removed from where it fell to the lawn of 'Homemead', Heacham. A sentry from the 1/1st Lincolnshire Yeomanry and a local policeman make sure the onlookers keep back from it on the morning after the Zeppelin raid of 19 January 1915. If it had gone off none of them would have stood a chance.

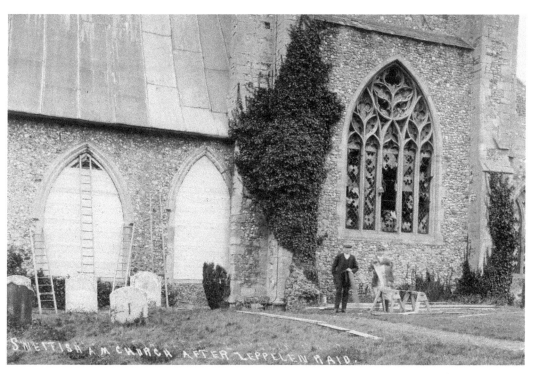

Boarding up the shattered windows of St Mary's Church, Snettisham, after the blast damage from the Zeppelin bomb that exploded in Mr Coleridge's meadow near the Sedgeford Road on the night of 19 January 1915.

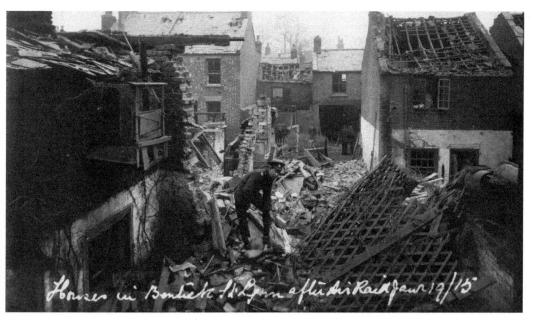

A soldier of the Worcestershire Yeomanry lifts up bloodstained bedclothes from among the wreckage of the homes of the Goate and Fayers families on Bentinck Street, King's Lynn, where Percy Goate (fourteen) and Alice Maud Gazley (twenty-six) were killed during the Zeppelin raid on 19 January 1915.

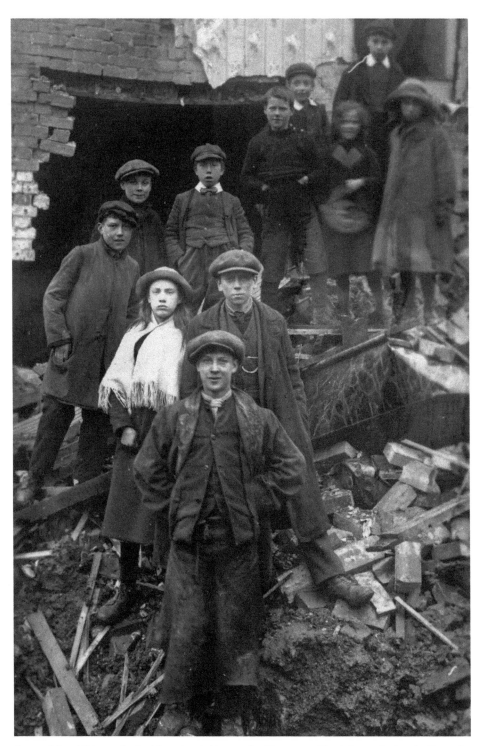

Some of the children who had been buried in wrecked houses at King's Lynn during the Zeppelin raid on 19 January 1915. Photographers and reporters came from far and wide to capture images and report on the aftermath. This photograph was taken by Wisbech photographer Lilian Ream.

Soldiers from 2/4th Battalion, the Norfolk Regiment and the Suffolk Regiment, gather in and around the crater left by a Zeppelin bomb dropped at the rear of No. 44 Denmark Road, Lowestoft, on 16 April 1915.

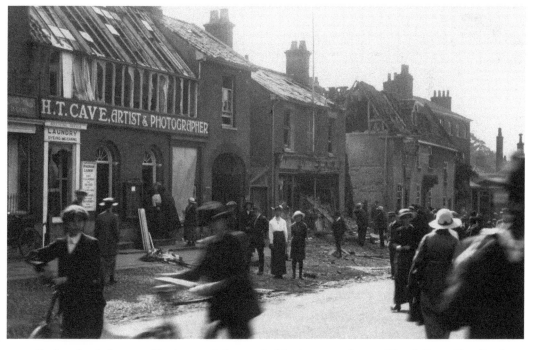

Curious locals linger and look around the wrecked business premises on Church Street, East Dereham, after the Zeppelin raid on the evening of 8 September 1915. As a result of the bombing on the town two people were killed, two subsequently died of wounds and six more were wounded.

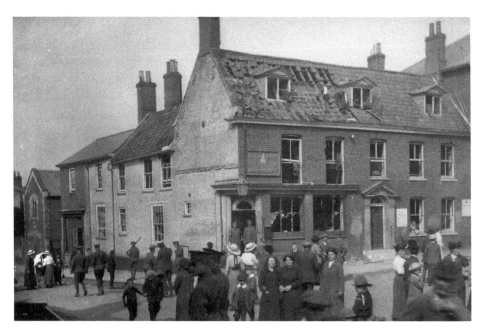

Headquarters of 5th Battalion, the Norfolk Regiment, showing the damage caused during the Zeppelin raid on 8 September 1915. On that fateful night local watchmaker and jeweller Harry Patterson was found dead in the doorway after he had been hit in the chest by a piece of bomb casing.

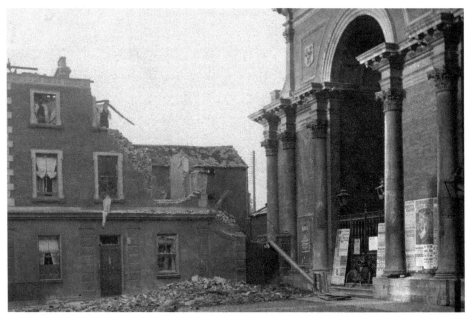

East Dereham Corn Hall, nearby houses and offices showing some of the damage they suffered during the air raid of 9 September 1915. Mr Catton, the occupant of the building to the left, ran outside to see what all the commotion was about as Pte Leslie McDonald of 2/1st City of London Yeomanry (Rough Riders) ran inside to shelter as the bomb exploded and the house collapsed. Pte McDonald was extracted alive from the rubble but later died from his injuries.

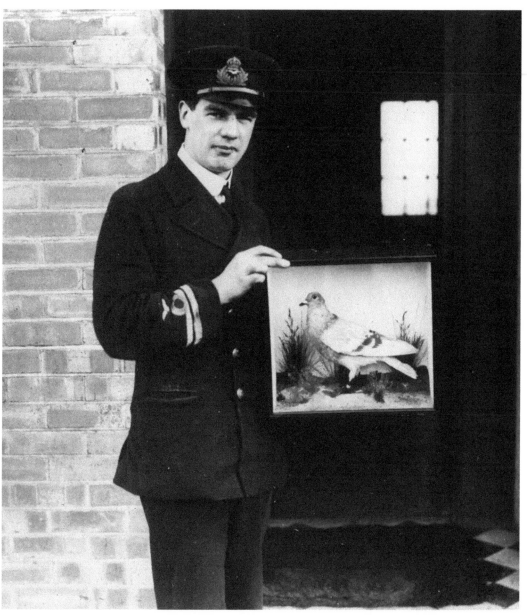

Pigeon No. NURP/17/F16331 stuffed and mounted in his box for display in the Officers' Mess at RNAS Great Yarmouth, 1917. Squadron Commander Vincent Nicholl was flying a DH4 aircraft with Flt Lt Trewin from RNAS Great Yarmouth on an anti-zeppelin patrol when its engine seized and the aircraft came down in a rough North Sea 75 miles from the British coast and soon sank. Flt Lt Bob Leckie piloting flying boat 866 went to their rescue and his crew managed to haul the two nearly drowned officers out of the water. There were now six men on the flying boat but all Leckie's attempts to get her off the sea failed. Four pigeons carrying messages of their location and situation were launched from the stricken aircraft. Three days later only Pigeon NURP /17/F16331 had made it back but was found dead with exhaustion on a beach. After all hope had been lost the rescue efforts were resumed and all six crew were rescued in the nick of time. A brass plaque was fixed to the display case of the pigeon bearing the simple inscription 'A very gallant gentleman'.

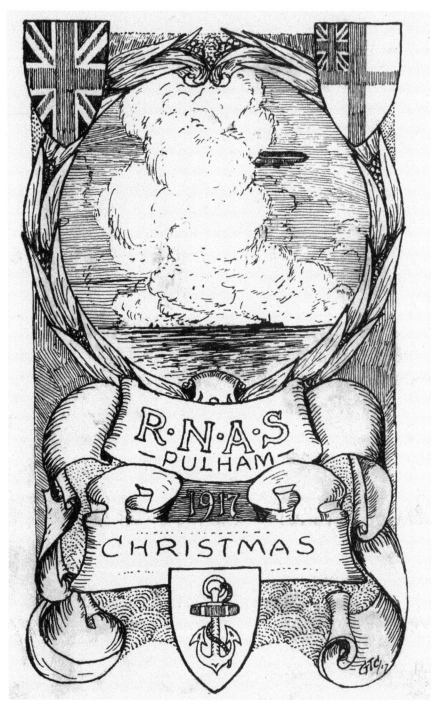

Artist drawn Christmas card from Royal Naval Air Service Pulham, 1917. The air station was operational from 1915 as a base for Coastal Type and SS (Submarine Scout) 'blimp' Airships never intended for offensive combat roles; they were for observation and patrol of coastal areas looking out for enemy shipping and U-boat movements. Far smaller than the German Zeppelins, these little airships flying over the Norfolk were soon nicknamed 'Pulham Pigs'.

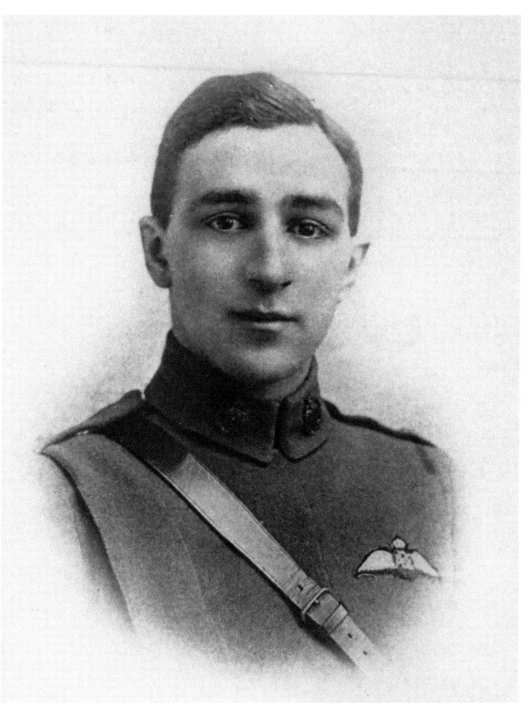

Lt Myer Levine, RFC, 1917. Born in Norwich in 1896 and raised in Cromer and Overstrand, he was educated at Bracondale School in Norwich and Paston School, North Walsham. A young man of great promise with a fine baritone voice, he had joined up with the Northumberland Fusiliers in 1915, rose through the ranks and was commissioned into the Royal Flying Corps in 1918. He had gained his wings in 53 Squadron but was tragically killed in a mid-air collision over Stamford, Lincolnshire, on 8 May 1918.

Norfolk Constabulary.

PUBLIC NOTICE.

DAYLIGHT
HOSTILE AIR RAIDS

When hostile aircraft are within such a distance of

WATTON

as to render an attack possible, the public will be warned thereof by the following signals:—

Each Day of the week (including Sunday)
"Danger" Signal.

Police and Special Constables will patrol the streets on cycles exhibiting cards bearing the words, "POLICE NOTICE, TAKE COVER."
The Constables will blow whistles frequently to attract attention.

"All Clear" Signal.

Police and Special Constables will patrol the streets on cycles exhibiting cards bearing the words, "POLICE NOTICE, ALL CLEAR."
The Constables will blow whistles frequently to attract attention.

The signals will be given during the period of **half-an-hour before sunrise to half-an-hour after sunset.** Every effort will be made to give **timely** warning of the approach of hostile aircraft, but the public should remember that the **"Danger"** signal will be given when **Real Danger** is apprehended in which event they should **Seek Shelter** with all speed.

Persons still in the open should take what shelter is afforded by lying in ditches, hollows in the ground, &c.

It is recommended that, in the event of raids during school hours, children should be kept in the school until the **"All Clear"** signal is given. Likewise, workpeople at factories, etc., should remain on the premises in whatever shelter is afforded.

Horses and other animals should be stabled or secured in some manner and should not be abandoned in the streets.

J. H. MANDER, Captain,
Chief Constable.

County Police Station,
Castle Meadow, Norwich,
January, 1918.

Daylight air raid warning poster for Watton, 1918. The later war years still saw Zeppelin raids by night but the new danger were the Gotha bomber aircraft that frequently passed over East Anglia on their way to their regular target of London in daylight. Thus, in 1918, posters advising of the warning signals and action to be taken in the event of a daylight air raid were published under the authority of the Chief Constable for every town across the county.

Major Egbert Cadbury DSC DFC and Captain Robert Leckie DSO DSC DFC photographed at RNAS Great Yarmouth a few hours after they shot down Zeppelin L70, over the sea just off the Norfolk coast near Wells on 5 August 1918.

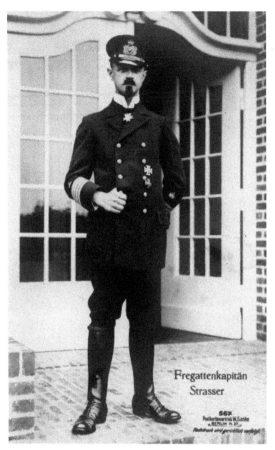

Fregattenkapitän
Strasser

S6F
Postkartenvertrieb W.Sanke
«BERLIN N. 37.»
Nachdruck wird gerichtlich verfolgt.

Left: Fregattenkapitän Peter Strasser, Chief of the Imperial German Naval Airship Division and the main proponent for Zeppelins in combat during the First World War, was aboard the Zeppelin L70 and died along with all of the other crew when she was brought down in a ball of flames off Wells by Cadbury and Leckie on 5 August 1918.

Below: RAF Sedgeford Band, Peace Day, July 1919. Sedgeford had been a night landing ground during the war years for aircraft flying out from Great Yarmouth in pursuit of enemy aircraft, especially Zeppelins. Even though it was over a year previously that the RAF came into being most of these men are still proudly wearing their khaki Royal Flying Corps uniforms and RFC cap badges.

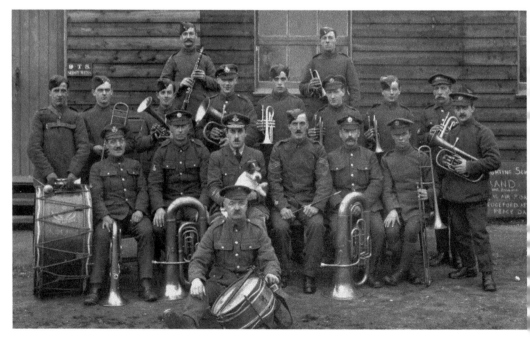

Ground crews and support staff including members of the Women's Royal Air Force, No. 3 Acceptance Squadron, RAF Mousehold, Norwich, 1918.

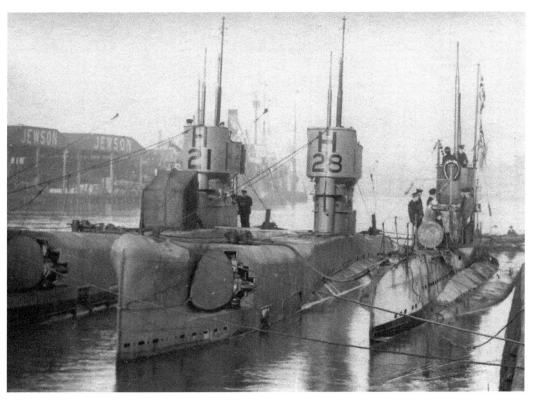

Two British 'H' class submarines lie alongside a captured German coastal type submarine at Hall Quay, Great Yarmouth, 1919.

CHAPTER 5
Wartime Norfolk

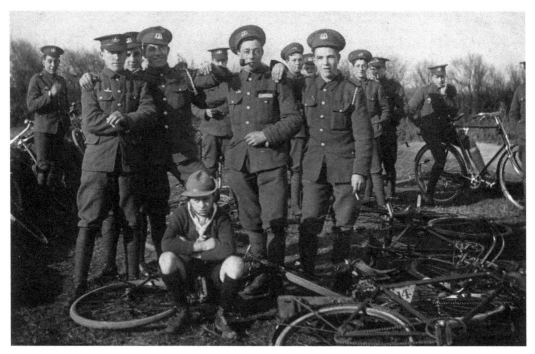

Members of 1/6th Battalion, the Norfolk Regiment (Cyclists) (T. F.), with their Boy Scout messenger 'somewhere on the Norfolk coast', 1914. When war broke out the defence of the British coastline was entrusted to mounted Territorial Force units of cyclists and yeomanry.

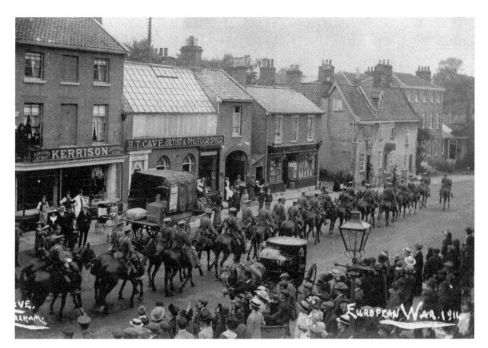

Mounted troops riding up Church Street, East Dereham, 1914. The first horse mounted troops for quick response in the event of invasion in Norfolk were part of the 1st Mounted Division of Yeomanry, and lines of uniformed riders, horses and wagons clattering along country lanes and through villages and towns soon became a familiar sight in the weeks and months after the outbreak of war.

A fine study of a trooper of the Derbyshire Yeomanry and his mount, Norfolk, 1914. He is armed with both a sword and a rifle; the latter rests in its leather gun bucket to the right of the rider – the butt of the rifle is just visible.

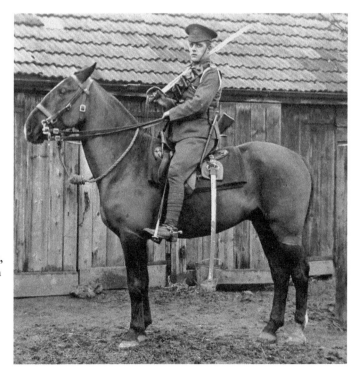

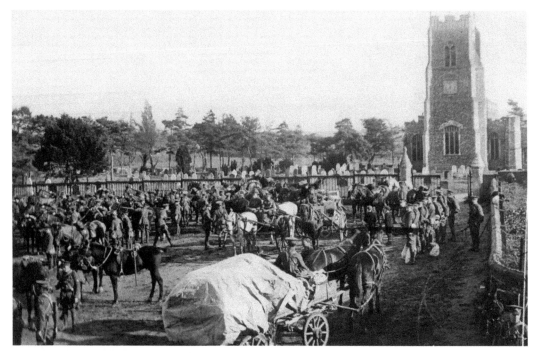

Men, horses and wagons of 1/1st Cheshire Yeomanry arrive at Church Plain, Loddon, 1914. They were housed in wooden huts and stables on Langley Park. During November 1914 sixty men of the squadron had been sent every working day to assist the contractors in the construction of the camp.

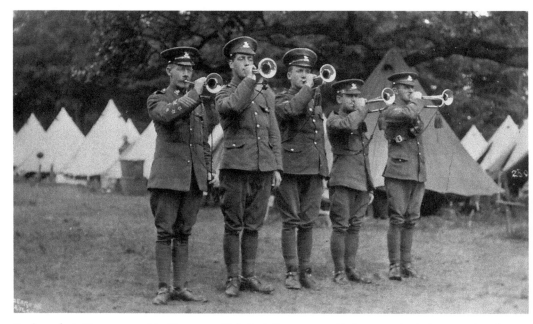

Buglers of 1/1 Montgomeryshire Yeomanry, Holt Park Camp, 1915. By late 1914 both the 1st and 2nd Mounted Divisions had been drafted to East Anglia to patrol the coast. A number of the Yeomanry units based in North Norfolk were from Wales and were remembered for years afterwards for their wonderful choirs.

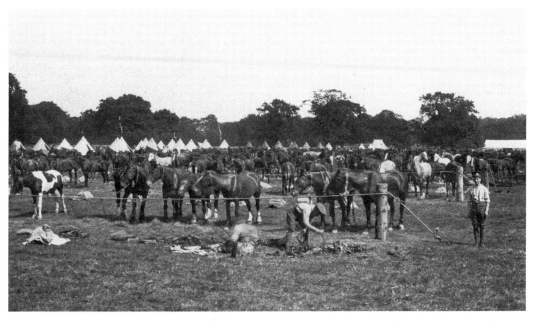

1/1st Pembroke Yeomanry, Westwick Park Camp, September 1915. Soon after the outbreak of the First World War it seemed like almost every country estate and park across Norfolk, especially those near the coast, had rows of white tents accommodating soldiers and horse lines spring up across them.

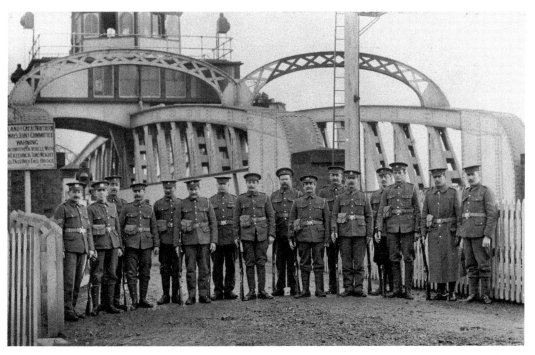

Members of the Norfolk National Reserve at Cross Keys Bridge, Sutton Bridge, on the Lincolnshire and Norfolk borders, c. 1914. The National Reserve was made up of old soldiers from both the regular and Territorial Force who volunteered to serve on home defence duties such as guarding key places like bridges, gasworks and military camps to free younger, fitter men to serve at the front.

First parade of the Norwich Volunteer Training Corps, December 1914. As War Emergency Committees met to plan evacuation measures in the event of invasion, there were also plans made for the construction of defences and rapidly local men too old to join up were forming into groups to defend the positions until the military arrived. All such units were soon taken under the national Volunteer Training Corps scheme. In many ways these men were the forerunner of the Home Guard in the Second World War.

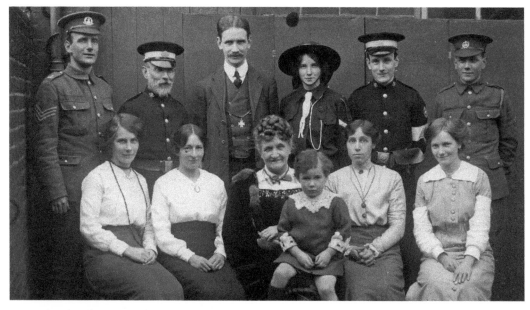

Doing their bit: the Randall family of Cromer, 1914. Father of the family Mr Robert Laurence Randall (standing second from left) was one of the founder members of the first St John Ambulance Brigade Division in Norfolk in 1901 and his son Harold was also a member. On either end of the back row are Sgt Theo Randall, 5th Battalion, the Norfolk Regiment (far left), and Raymond Randall, 10th (Service) Battalion, the Essex Regiment (far right). Daughter Enid joined the group in her Girl Guide uniform too. Mother, daughters and even young Robert Randall Jr did their bit helping with fund raising events for comforts for service personnel and war charities during the war. A fifth son, Reg, was away serving with his battalion when this photograph was taken. All the brothers that were old enough went on to serve in the armed forces and the family were very fortunate that all of the boys returned home at the end of the war.

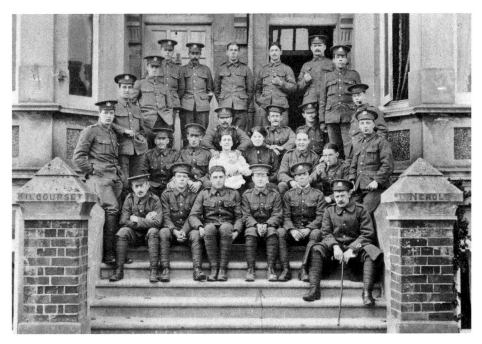

Some of the 2/6th Battalion, the Norfolk Regiment (T. F.) (Cyclists), and their landladies, in front of their billet at Bridlington, 1914. Just like their counterparts in the 4th and the 5th Battalions, the 6th Battalion raised two reserve battalion. The 2/6th was deployed to the Yorkshire coast and based in Bridlington on anti-invasion patrols.

Some of E Company, 2/6th Battalion, the Norfolk Regiment (T. F.) (Cyclists), Bridlington, 1914. They were nicknamed the 'Half Crown Holyboys' after their battalion numbering (2/6 was half a crown in old money and the Holyboys was old nickname of the regiment). These lads have a mix of uniforms, some of them in 'Kitchener blue' stopgap uniforms while others have to make do with knitted jumpers and cap comforters.

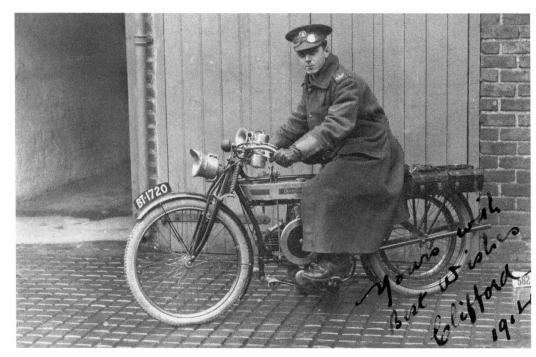

A fine study of one of the motorcyclists of 2/6th Battalion, the Norfolk Regiment (T. F.) (Cyclists), on one of the Douglas motorcycles the battalion used to patrol the Yorkshire coastline around Bridlington, 1914.

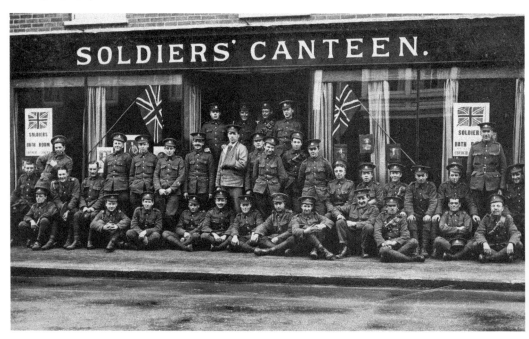

Soldiers' Canteen, Sheringham, c. 1914. In the centre is one wounded soldier in his hospital blues, and the rest were troops deployed to defend the Norfolk coast in the event of an invasion. They include members of The Essex Regiment, Nottinghamshire (Sherwood Rangers) Yeomanry, and Royal Sussex Regiment.

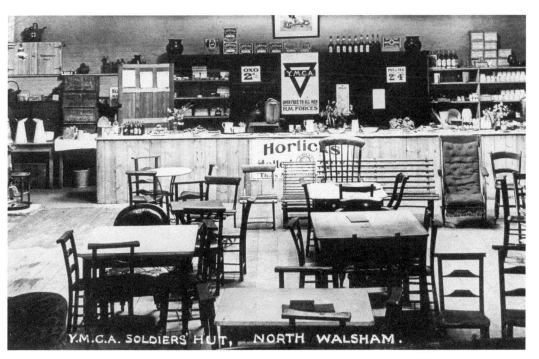

YMCA Soldier's Hut, the Church Rooms, North Walsham, 1915. The huts could be found on military camps all over Norfolk and in villages, towns and cities where large numbers of soldiers were stationed or in training. In towns and cities the 'huts' were usually in public buildings and church halls.

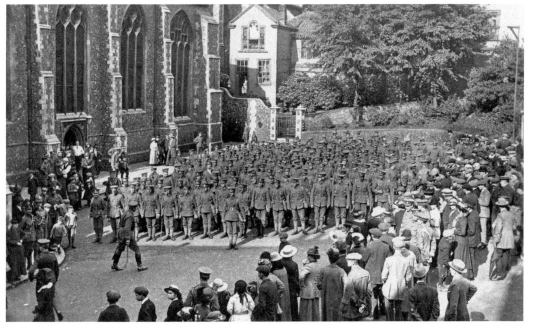

Company parade of soldiers in front of St. Andrew's Hall, Norwich, c. 1915. St Andrew's became the largest YMCA centre in the county hosting thousands of soldiers and supplying thousands of hot cups of tea, writing paper and snacks to locally based troops every week.

Soldiers of 2/4th Battalion, the Northamptonshire Regiment, guarding their company transport on the Cattle Market, Norwich, 1914.

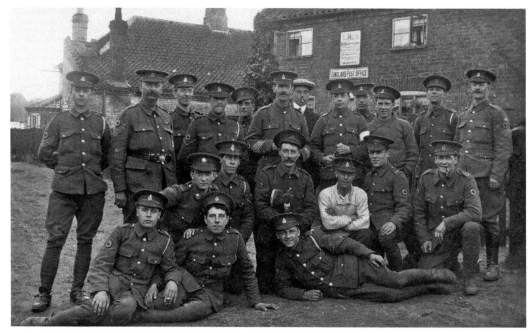

Territorial Force Royal Army Medical Corps soldiers and Army Service Corps drivers in front of Ringland Post Office, Norwich, 1914. The rural villages of the county had never previously encountered so many troops descending on them and many villages would encounter a variety of units staying nearby or passing through during the war.

Just " a line " from HOLT.

With troops stationed all over the county, local shops and post offices often stocked specially overprinted greetings cards for the troops to send back home, like this one from Holt.

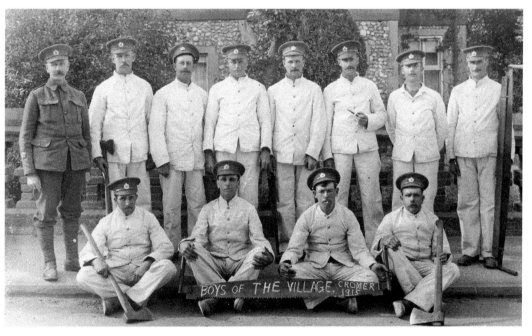

'Boys of the Village' Royal Engineers in their white work fatigues, Cromer, 1915. Wooden hutted encampments, defences and rifle ranges were built by Royal Engineers or contractors with second line troops as labourers all across Norfolk during the war.

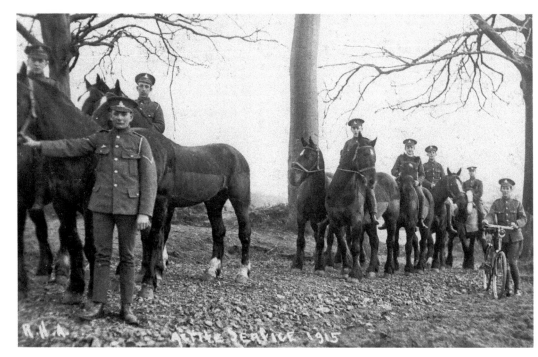

Royal Horse Artillery Territorials from the 1st Mounted Division exercising the horses of their gun teams near Aylsham, 1915.

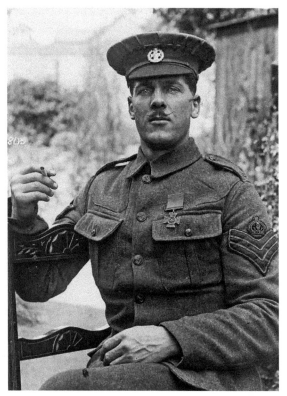

The first Norfolk man to receive the Victoria Cross during the First World War was Wymondham-born Company Sergeant Major Harry Daniels, 2nd Battalion, the Rifle Brigade. Harry had a tough start to life when both his parents died and he was placed in the Norwich Boy's Home on St Faith's Lane. Harry joined the Rifle Brigade as a boy soldier before the war and had risen up the ranks through hard work, natural abilities in leadership and fine physical fitness. He was awarded his VC at the Battle of Neuve Chapelle on 12 March 1915 for voluntarily rushing forward under fire with A/Cpl Cecil Noble and successfully cutting a gap in barbed-wire entanglements that would have impeded their company's advance and undoubtedly saved many lives in doing so. Both men were wounded in the process and were awarded our nation's highest gallantry award. Sadly Cecil Noble died of his wounds but Harry did recover and had a hero's return to Norwich where he was presented with the Freedom of the City.

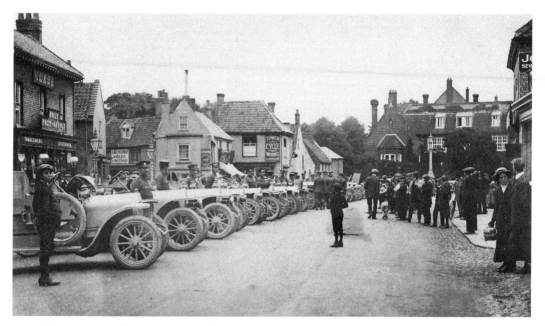

Motorcar coastal patrol column of 2/25th London Regiment at Holt, 1915. Before the war motorcars were seen occasionally in the rural areas of Norfolk. As the war progressed more motor vehicles were acquired for military service and motor patrols certainly drew great interest from the locals.

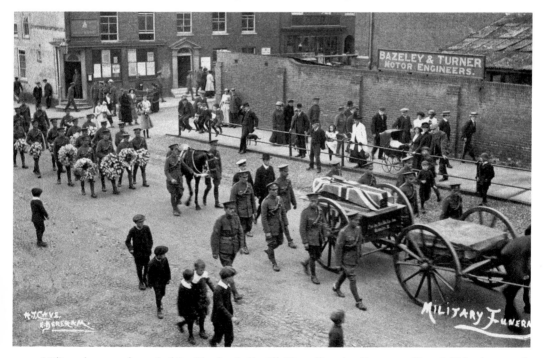

Military honours funeral of Pte Charles A. Sheriff, City of London Yeomanry (Rough Riders), proceeds up Church Street, East Dereham, on 21 July 1915. He had died on 18 July 1915 from injuries he had sustained in an accident on the road to Norwich. His grave in East Dereham cemetery is now marked with a Commonwealth War Graves Commission headstone.

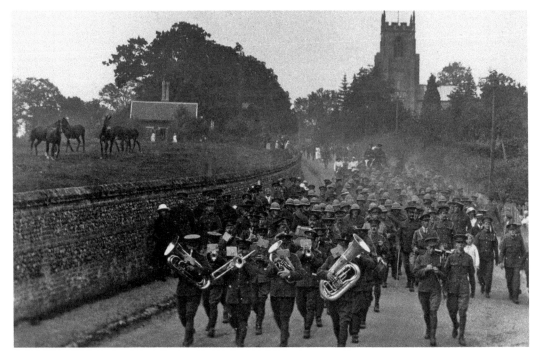

The squadron band leads the men of the 1/3rd County of London Yeomanry (Sharpshooters) out of North Elmham shortly before their departure for Egypt in 1915. Many of the Territorial and Yeomanry units raised in, or drafted over, to East Anglia during the invasion scares of the first months of the war were sent overseas to the Middle East and Gallipoli in 1915.

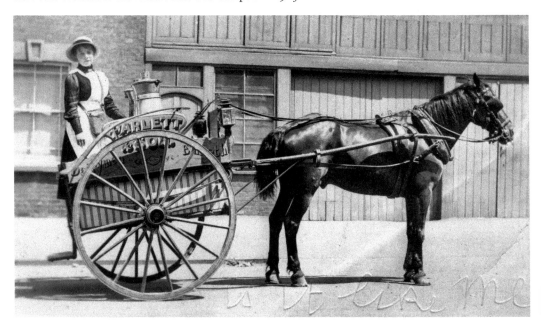

Parlett & Sons of Emneth's milk delivery cart and delivery girl, c. 1915. When our local lads went to war many of their sisters stepped in to help with family businesses and shops, even delivery rounds. As more men left to serve more and more women worked in an unprecedented range of jobs on the Home Front.

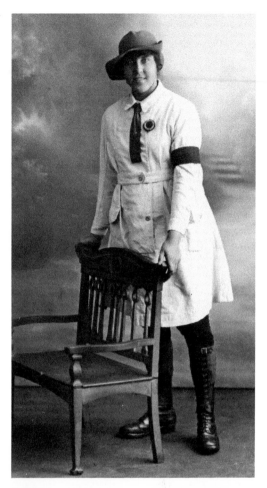

Right: A smart member of the Women's Land Army, Norfolk, 1917. As Britain feared another poor harvest caused by floods and wet weather and with the U-boat menace sinking thousands of tonnes of merchant shipping, every acre of land counted and the trained women of the Land Army were a welcome addition to the workforce on the land.

Below: Women munitions workers, Norwich, *c.* 1916. The term 'munitions' did not just refer to making gun shells but could be applied to any work that 'fed the guns', from pulling flax to make rope handles for ammunitions boxes to making army boots. Hundreds of girls were employed in Norwich making boots, fuses and aircraft during the First World War.

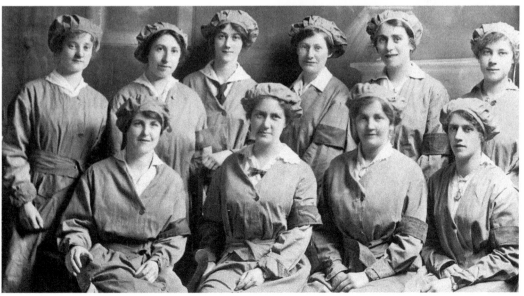

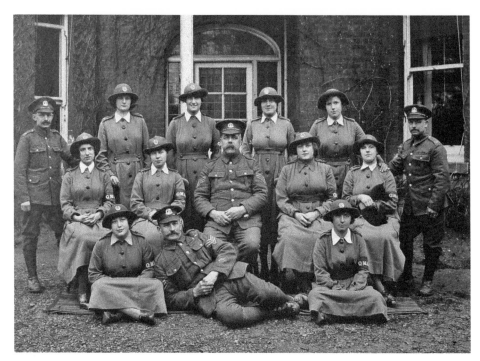

Clerical workers and storekeepers of Queen Mary's Army Auxiliary Corps with members of the Norfolk Regiment headquarters permanent staff, 1918. Despite volunteering themselves ready to serve from the very start of the conflict women were only officially accepted as auxiliary units in the Army, Royal Navy and Royal Air Force late in the war when every man that was fit for active service was needed and women were drafted in under the banner of 'Free a Man for the Front'.

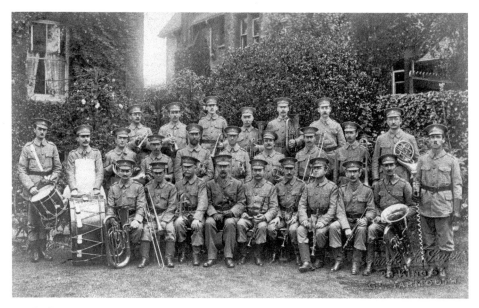

Band of 1st Battalion, the Norfolk Volunteers, Great Yarmouth, c. 1915. As ever, bands were popular for recruitment and with so many men away at the front of the volunteers bands were certainly kept busy with parades, recruitment events and special occasions on the Home Front.

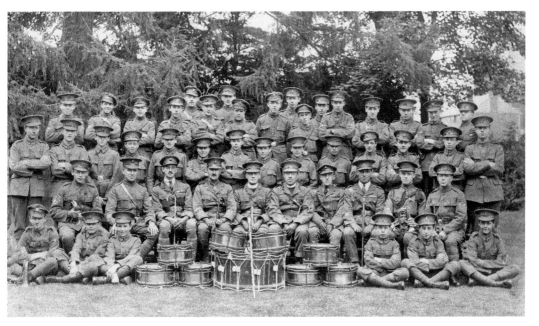

The Norwich Church Lads Brigade, 1919. Raised before the First World War, the CLB had a number of units attached to churches around the city of Norwich. The boys learned drill and how to march to drums, learned their bugle calls and attended camps run along military lines. They joined in many parades during the war and helped out with street collections and collections of comforts for the fighting forces. When they attained the age of eighteen many of them joined up too and did their bit in the fighting forces.

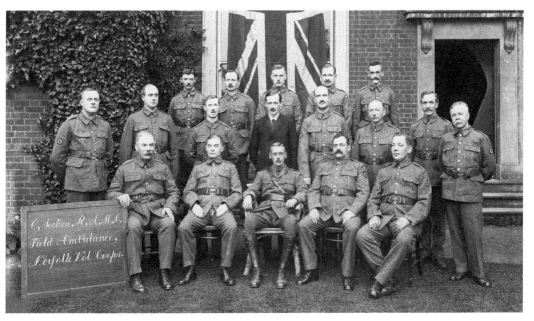

Dr John Kitton Howlett (seated centre) and the men of C Section, Royal Army Medical Corps Field Ambulance, Norfolk Volunteers, East Dereham, c. 1915. The ambulance sections of the Norfolk Volunteers trained in the loading and unloading of stretchers and transport of returned wounded troops and assisted as ward orderlies in their local auxiliary war hospitals.

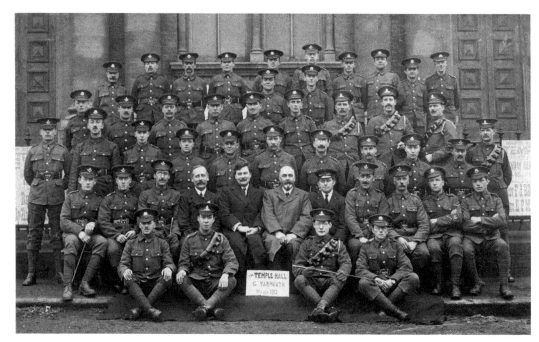

Mr Edward Wesley Kerrison, president of the Adult Bible Class (seated centre right), and locally based troops from a variety of regiments, including Royal Field Artillery, 2/6th Battalion, Cheshire Regiment, and 2/4th Battalion, King's Shropshire Light Infantry, at the Primitive Methodist Temple Hall, Great Yarmouth, March 1917.

'The Wymondham Old and Bold', officers, NCOs and men of the Wymondham Company of the Norfolk Volunteers, 1918. When conscription was introduced in January 1916 men of service age but found unfit for active service abroad would often be given a choice of being placed with home garrison units, which could mean they would be sent anywhere in Britain, or remaining at home on the condition they joined their local volunteers.

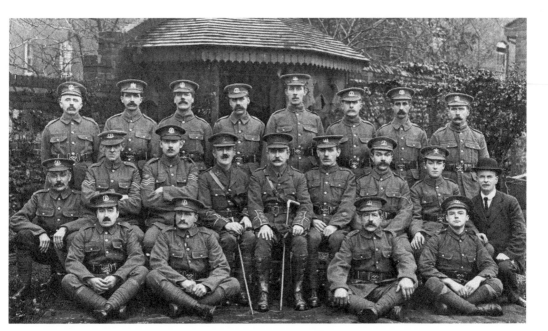

Officers, NCOs and men of the North Walsham Company of the Norfolk Volunteers, 1918. The volunteers were issued with khaki uniforms like those worn by their Regular Army counterparts from 1916, and in July 1918 the VTCs became volunteer battalions of their local line regiments and were permitted to wear their county regiment badges. After the Armistice in November 1918 the volunteers units were gradually stood down and were finally disbanded in 1919.

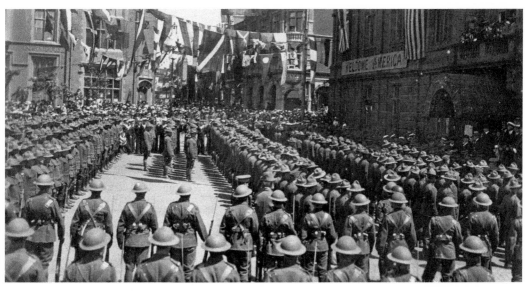

Welcome America! On 4 July 1918 over 500 American troops celebrated Independence Day in Great Yarmouth. Arriving at Vauxhall Station, the Americans marched along North Quay to Hall Quay where they were given an official welcome by the mayor in front of the Town Hall. They then marched along Regent Road to the North Parade and the Wellesley Recreation Ground where they played a game of baseball. Their route was lined by cheering people and Stars and Stripes of all sizes were flown and waved by exuberant locals.

War Hospitals

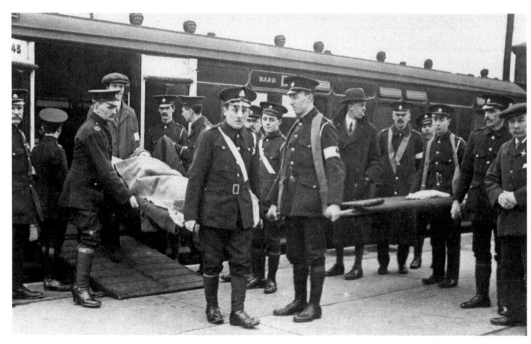

Members of No. 15 Voluntary Aid Detachment (City of Norwich), British Red Cross Society, working with members of the RAMC to remove wounded soldiers from the first train of wounded brought to Norfolk shortly after its arrival at Thorpe Station, Norwich, 29 September 1914. The Red Cross men would assist the removal of the wounded on foot and on stretchers to waiting ambulances that would take them to one of the local war hospitals.

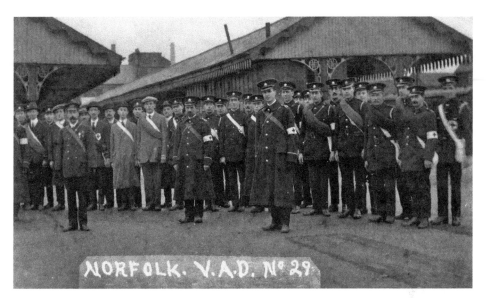

Stretcher bearers of No. 29 Voluntary Aid Detachment (Norfolk), British Red Cross Society, awaiting a train load of wounded soldiers on Norwich City Station, 1914. During the war some 40,498 patients were handled in 317 convoys by the volunteers of the Norwich Voluntary Aid Detachments of the British Red Cross Society.

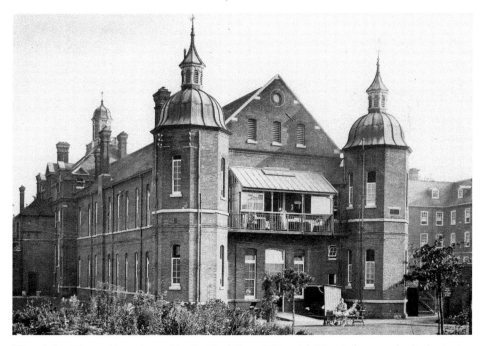

Wounded soldiers taking air outside the Norfolk and Norwich Hospital, 1915. At the beginning of the war the only extant hospital for the reception of wounded in the county was the Norfolk & Norwich Hospital. On the outbreak of war, the hospital offered fifty beds, which the Admiralty gladly accepted, with a further fifty beds four days later. These beds were soon taken by soldiers and the hospital capacity to take returned wounded soldiers was expanded into specially erected prefabricated buildings and even marquees.

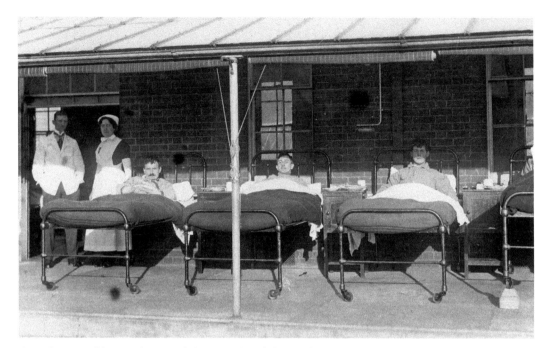

Convalescent soldiers under one of the verandas of the Norfolk & Norwich Hospital, 1915. During the First World War (and before) ensuring patients got plenty of fresh air was a key part of many treatments, especially those who suffered chest injuries, sickness and, from 1915, those who had been caught in a gas attack.

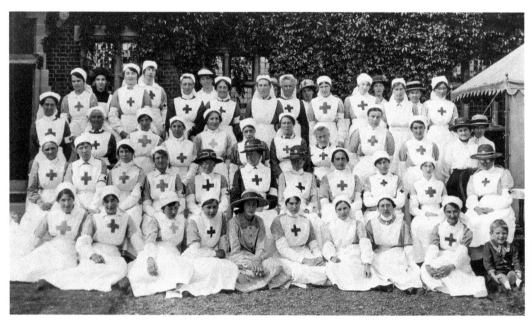

Commandant Maude Cator and the staff of Woodbastwick Hall Auxiliary War Hospital, c. 1914. Opened on 28 September 1914, Woodbastwick Hall was the first auxiliary war hospital run under the auspices of the British Red Cross Society & Order of St John to open in Norfolk. When it finally closed in 1918 some 1,113 wounded soldiers had been cared for there during the course of the war.

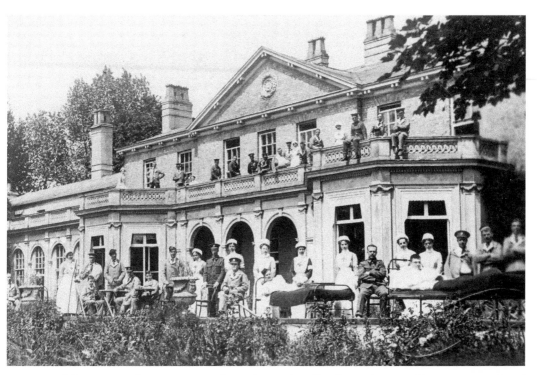

Brundall House Auxiliary War Hospital complete with staff and convalescent soldiers, 1915. Purchased by Boulton & Paul director William Ffiske in 1914, the house was converted to an auxiliary war hospital opened on 12 October 1914.

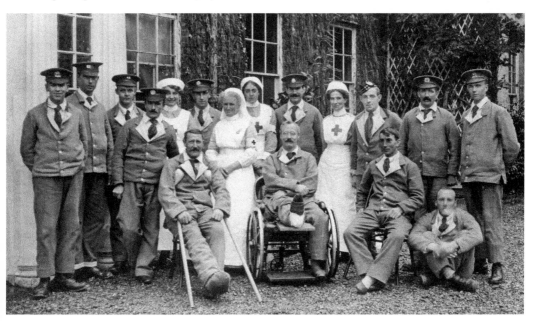

Nurses and convalescent soldiers from a variety of British regiments in front of Brundall House Auxiliary War Hospital, 1915. Brundall House closed as an auxiliary war hospital on 1 October 1916 having nursed a total of 712 convalescent soldiers.

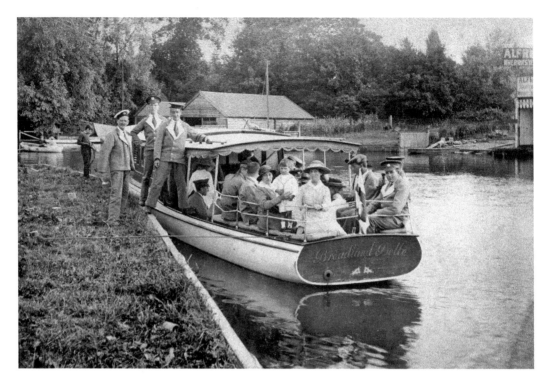

Convalescent soldiers were often treated to entertainments and outings on the Norfolk Broads with some of the volunteer nurses, local hospital visitors and their families. This kept their spirits up and exposed them to yet more fresh air to aid their recovery.

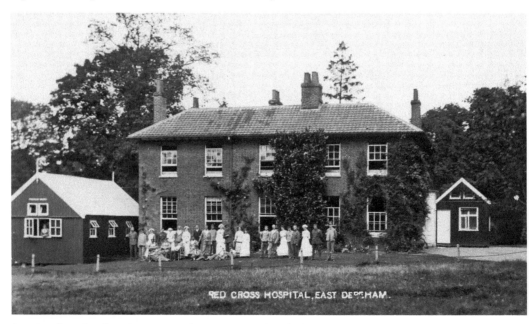

East Dereham Auxiliary War Hospital, 1915. Housed in the local rectory, it opened on 16 November 1914 and an annexe was built to the side of the house to accommodate more convalescent troops soon after. By the time it closed on 5 April 1919, some 2,067 convalescent soldiers had been cared for there.

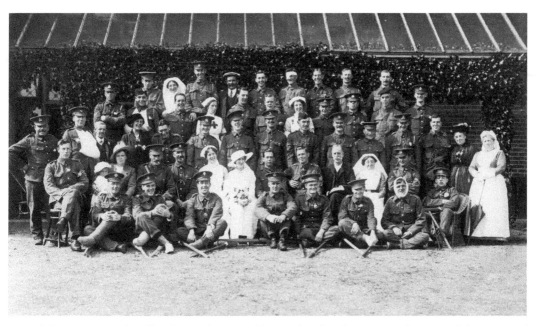

A happy group of staff and convalescent soldiers gather for the camera when one of the nurses of the Fletcher Convalescent Hospital, Cromer, got married in 1915. A number of Norfolk's pre-war sanatoriums and convalescent homes also cared for convalescent soldiers during the First World War.

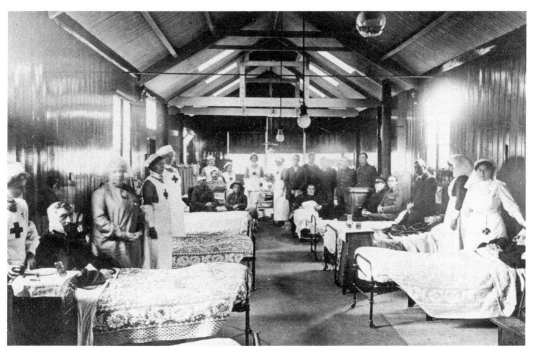

Overstrand Auxiliary War Hospital c. 1915. It was established by Lady Battersea in the Reading Room in the grounds of her home, The Pleasaunce. The hospital opened on 3 November 1914 and encompassed another premises on Harbord Road that cared for convalescent Belgian soldiers. The hospital building is now used as Overstrand Parish Hall.

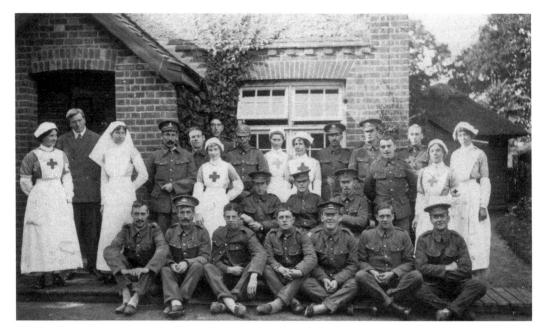

Staff and convalescent soldiers at Ingham Hall Auxiliary War Hospital. Auxiliary war hospitals usually had something of a 'family' atmosphere. Each auxiliary hospital would be established by a local committee and run by a local Voluntary Aid Detachment, often specifically raised for that function. The commandant was often the wife of the owner of the house and the Red Cross VAD nurses that worked there would mostly have come from the local community while the medical care supplied was directed by a medical officer (usually a local doctor) and the superintendent (a trained nurse).

Thornham Auxiliary War Hospital, 1917. Opened on 5 January 1915 and closed on 31 January 1919. A total of 617 convalescent soldiers were treated here. When the last of the sixty-two Norfolk Auxiliary War Hospitals closed in 1919, a total of 1,377 beds had been provided and they had cared for 27,446 convalescent soldiers.

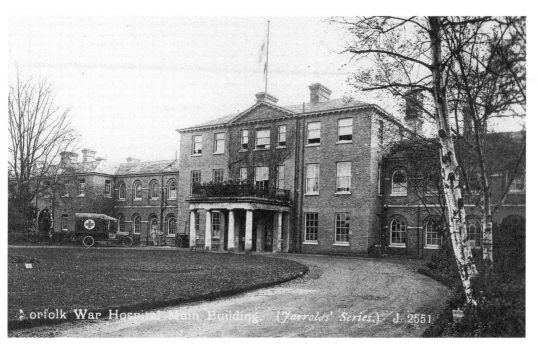

The Norfolk War Hospital took over the old Norfolk Lunatic Asylum in Thorpe and was ready to receive its first patients in April 1915. As the numbers of returning sick and wounded from the battlefields increased, the pressure to create more hospital beds intensified, so early in 1915 the War Office introduced a scheme to evacuate the patients of extant county asylums for the mentally ill to other, smaller facilities and convert the largest premises into war hospitals.

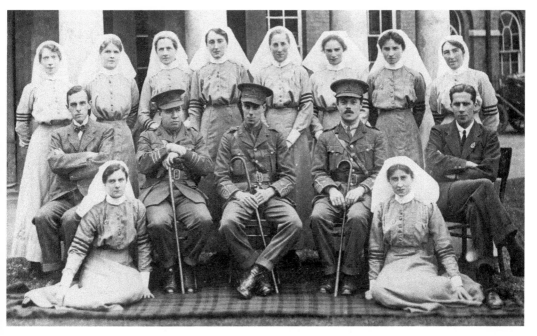

RAMC officers and Queen Alexandra's Imperial Military Nursing Service nurses at the Norfolk War Hospital, c. 1916. The war hospital was, however, predominantly staffed by trained civilian nurses.

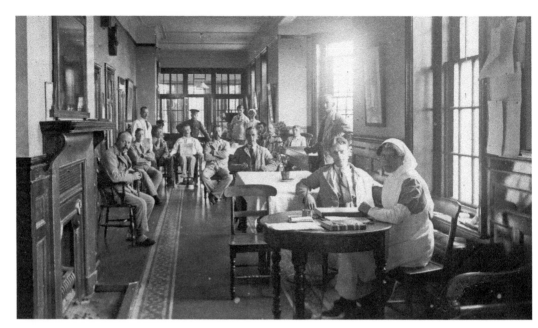

Inside one of the day rooms of the Norfolk War Hospital, *c.* 1916. Here the convalescent soldiers would have a chance to socialise, play games together, write letters home and if suffering with injured legs or feet begin to take a few steps under the supervision of a nurse.

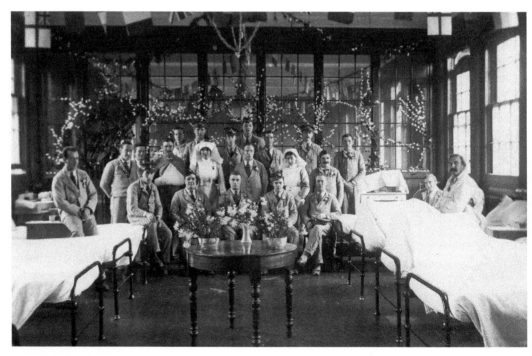

Convalescent soldiers in one of the wards of the Norfolk War Hospital. Note the decorations, flowers and flags used to brighten up the ward. Soldiers were encouraged to rise and stand to attention by their bed if they were able when the doctor inspected the wards. Those who were bed bound were expected, if they could, to lay at attention.

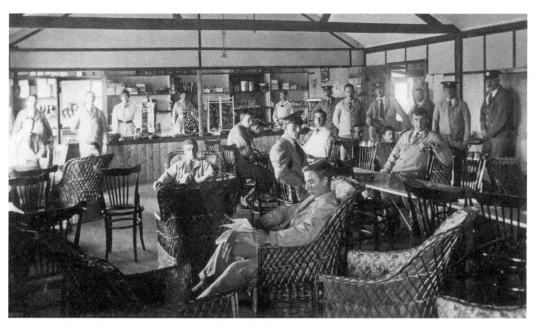

The Thorpe Annexe Canteen at the Norfolk War Hospital, *c.* 1915. The canteen was a popular place for convalescent soldiers to gather and buy treats such as McVitie and Price biscuits and Wills Woodbine cigarettes. There was also a good range of illustrated postcards on wartime themes to write home on and a fine selection of regimental sweetheart badges to buy for the special lady in their life.

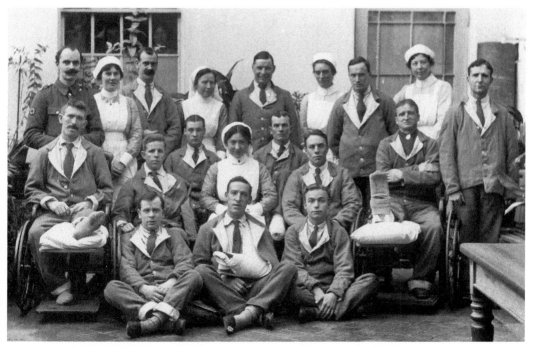

Ward orderly (standing far left), some of the qualified civilian nurses and convalescent soldiers at the Norfolk War Hospital, *c.* 1915. The Norfolk War Hospital and its annexes had 2,428 beds that cared for 30,000 sick and wounded soldiers between its opening in April 1915 and its closure in 1919.

A Norfolk 'Silver Badge man', 1918. Following a number of incidents in the early war years where discharged service personnel who did not have immediately visible wounds or conditions were taunted as cowards by those who thought they were evading military service, a distinctive Silver War Badge to be worn on the lapel was authorised in September 1916. Any soldier, regardless of if they had served at home or abroad, that had been given an honourable discharge was entitled to the badge.

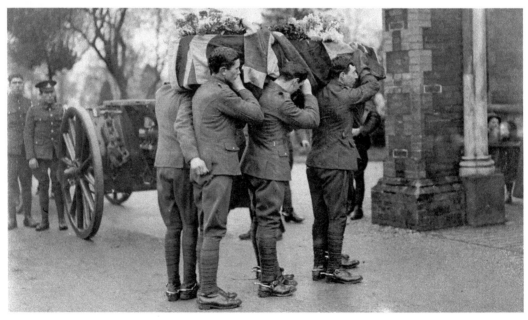

Military honours funeral, Norwich, c. 1915. If a soldier returned from the front to a British hospital sadly succumbed to his wounds, he would be given a funeral with military honours. Some of them were returned to their home towns or villages for burial but many were buried in a cemetery near to their hospital. This included the soldiers from Canada, Australia or New Zealand who lie, to this day, a long way from home.

CHAPTER 7
1918 Armistice and After

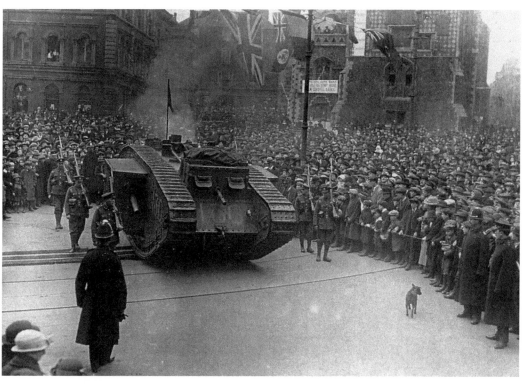

Nelson Tank manoeuvres into position by the Norwich Guildhall for Tank Week, 1–6 April 1918. The event was to raise funds for the war loan by encouraging people to buy war bonds. In Norwich alone Tank Week raised £1,957,000.

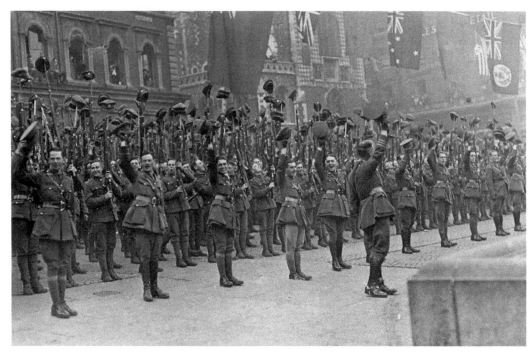

One almighty cheer goes up from the officers and men of 51st and 52nd (Graduated) Battalions, the Bedfordshire Regiment, on the announcement of the Armistice in Norwich Market Place on the eleventh hour of the eleventh day of the eleventh month in 1918.

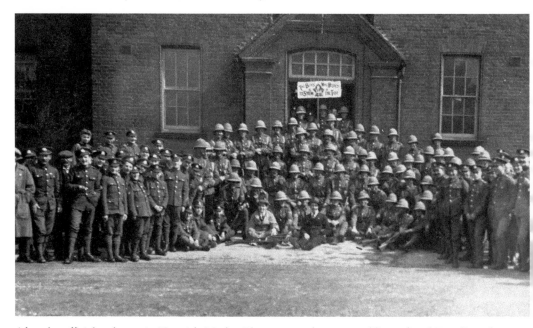

After the official welcome in Norwich Market Place past and present soldiers of 2nd Battalion, the Norfolk Regiment, gather for a less formal 'Welcome Home' at Britannia Barracks on 11 April 1919. Their war had been fought in Mesopotamia where they contended with climate and disease in addition to the dangers of battle.

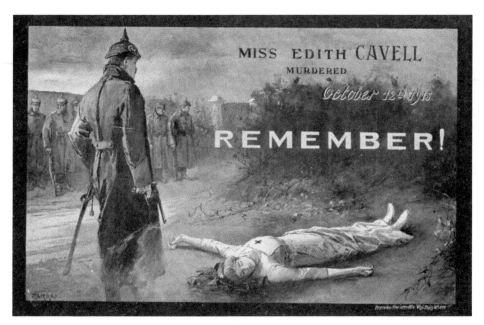

One of a variety of picture postcards depicting the execution of Norfolk-born nurse Edith Cavell by German firing squad on 12 October 1915.

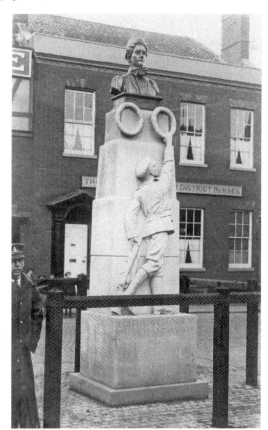

Norfolk never forgot its greatest heroine of the First World War and this memorial to Edith Cavell, inscribed with the simple legend 'Nurse, Patriot and Martyr', was unveiled by Queen Alexandra in front of a huge crowd that filled Tombland, Norwich, on the third anniversary of her execution, 12 October 1918.

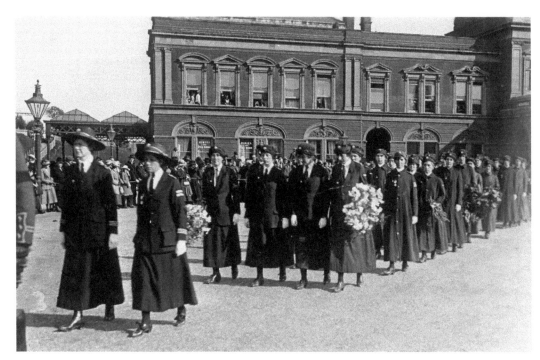

The official party from the Norfolk branch of the British Red Cross Society follow the gun carriage bearing the body of Edith Cavell as it leaves Thorpe Station and made its way to Norwich Cathedral and her final resting place of Life's Green on 15 May 1919.

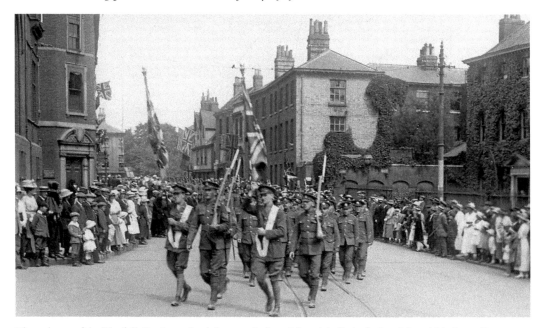

The colours of the Norfolk Regiment lead the parade from Norwich Cathedral on Norwich's Peace Day, 19 July 1919. With Norfolk men and women spread all over the world in a variety of theatres of war from the Western Front to Mesopotamia, it would take a while for their duties to end and for them to get back home again so a summer date of 19 July 1919 was set for the united Peace Day celebrations.

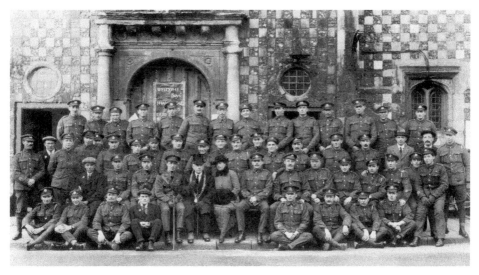

The mayor of King's Lynn with his wife and the local men who had returned to the town after being held as prisoners of war, 1919. Many of these men were members of the Norfolk Regiment and had been held in camps after being captured on the Western Front by Germans, but a few of them had also been held by the Turks after being captured in Gallipoli or Palestine.

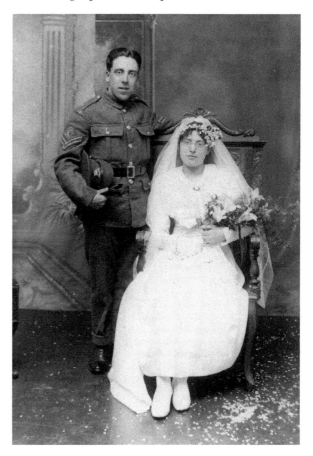

Cpl Arthur Shorten of the Queens Regiment and his bride Martha stop by at the photographers after their wedding at Magdalen Road Congregational Church, Norwich, 1918.

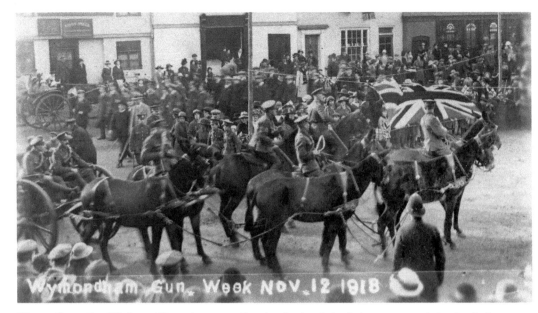

Wymondham Gun Week, 12 November 1918. Despite the Armistice being announced the day before the events had been planned for quite some time and still went ahead. It was very well attended, there was a parade led by a Norfolk Regiment band and people thronged the marketplace to see the mounted soldiers and the gun and limber pulled by a team of mules that had seen action in France. After just the first day £7,088 had been raised for the war effort.

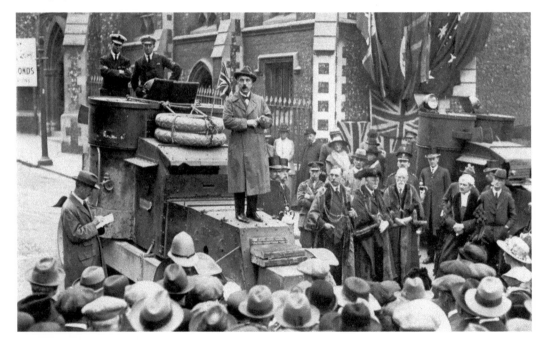

George Roberts, MP for Norwich and wartime Minister of Labour (1917–19), delivers a speech from the bonnet of one of the Anglo-Russian mission armoured cars parked outside the Guildhall, Norwich, on Victory Loan Day, 7 July 1919. Norwich came up trumps again, raising £1,281,000 (£880,000 of that sum was subscribed by Norwich Fire & Life Offices).

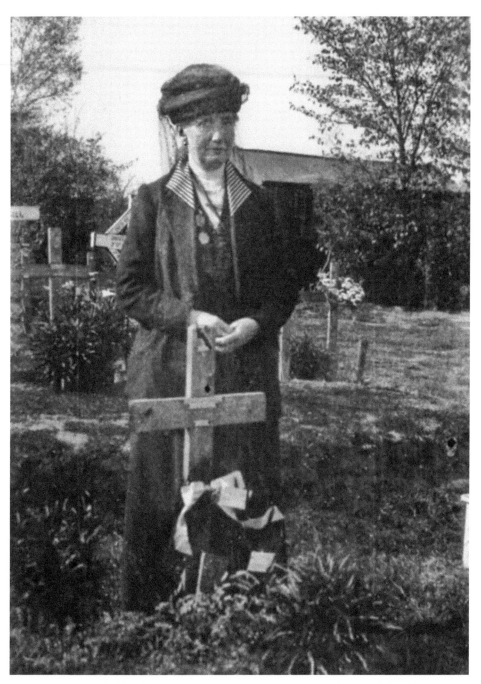

Mrs Margaret Scott-Pillow of The Grange, Thorpe Road, Norwich, visits the grave of her youngest son 2nd Lt Henry Montgomery Scott-Pillow RFC at Medinghem Military Cemetery, Belgium. He had been killed just ten days after he arrived back at the front after training as a pilot while flying near Ypres on 8 August 1917. Thousands of mothers, widows and family members made the journey across the Channel to visit their loved ones who lay forever in 'some corner of a foreign field' in France and Flanders after the war. Those from poorer backgrounds were assisted by charities and the British Legion to pay for the visit.

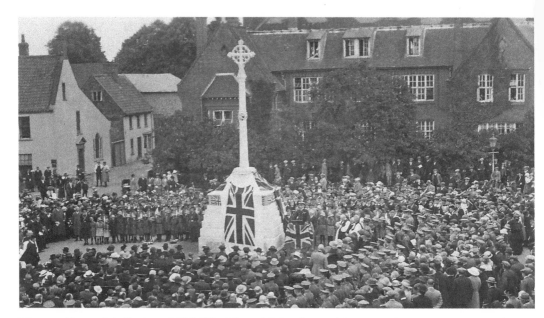

The unveiling and dedication of Holt War Memorial, Sunday 29 May 1921. Over 100,000 men and women of Norfolk served in the First World War, and around 11,800 of them lost their lives. War memorials remain silent sentinels bearing mute testimony to so many sad tales of loss. Sometimes several local lads all lost on the same day, sometimes brothers and extended family members. In the parishes of the city, towns and villages everybody knew someone who did not return. Nothing would ever be quite the same again.

Old Catton branch of the British Legion, c. 1930. After the war there were many ex-servicemen and their families who faced hard times through lack of employment or disablement that meant the returned soldier could not work as he did before, but the comradeship they knew in war remained in peace. Far more regimental associations were established than had ever been previously known and a wide variety old comrades associations were established, both locally and nationally, to help those in need.